IMAGES
of Modern America

EASTPOINTE

IMAGES
of Modern America

EASTPOINTE

Suzanne DeClaire Pixley

ARCADIA
PUBLISHING

Published by Arcadia Publishing
Charleston, South Carolina

Printed in the United States of America

Library of Congress Control Number: 2014943667

For all general information, please contact Arcadia Publishing:
Telephone 843-853-2070
Fax 843-853-0044
E-mail sales@arcadiapublishing.com
For customer service and orders:
Toll-Free 1-888-313-2665

Visit us on the Internet at www.arcadiapublishing.com

This book is dedicated to my children, Katy, Chris, Sherri, Lauri, and Molly, for supporting their mother through all of her endeavors.

CONTENTS

ACKNOWLEDGMENTS

The author gratefully acknowledges the previous work by members of the East Detroit Bicentennial Committee of 1976 and early members of the East Detroit Historical Society for their careful collection and preservation of data, photographs, and newspaper clippings pertinent to East Detroit history. Equally helpful with book research were the vertical files of the East Detroit Public Library reference department and the guidance of assistant librarian Sue Todd.

To Dave and Linda Wendt goes a huge thank you for sharing scrapbook information and photographs from the 1948–1956 city councils. Thanks go to Sue Young, Harvey Curley, Ken Giorlando, Leo LaLonde, Marco Catalfio, and Nick Sage for sharing their personal photographs. A special thank you is given to the City of Eastpointe for the use of the mayors' pictures; to Randy Altimus, Joyce Vincent, and Kimmie Sharp Rich for help with photographs and individual identification; and to Brent Avery for assistance with the Chapaton photographs.

The author is indebted to Sharon Arend, director of archives with Ilitch Holdings, for information and photographs from the Detroit Caesars. To Molly Pixley Gillespie goes a huge thank you for assistance with graphs and tables. She would also like to mention Partners in Architecture and Anderson, Eckstein, and Westrick (AEW) Engineering for your assistance.

There would be no book without the able guidance and extreme patience of Arcadia editor Julia Simpson and staff. Finally, the author would like to thank her friends and family for your patience, understanding, and support as the book made its way to completion.

INTRODUCTION

Historically, Eastpointe was slow to develop in the 19th century. Located halfway between the Macomb County seat of Mount Clemens and the rapidly growing river city of Detroit, it became a rest stop for tired horse-and-buggy drivers along the former Gratiot military plank highway. Historians made note that stagecoaches would stop at the main corners to refresh their passengers and horses and then be on their way to the next stop. Most of the area was agricultural in nature, with farmers growing food for their own consumption or to be sold at Eastern Market in downtown Detroit.

Businesses developed along that same road, bringing a collection of skilled tradesmen and people who could serve the traveler. Those same businessmen told their families and friends of all of the opportunities in the new area, which led to its development. Initially part of an area township, it eventually grew in population and became the independent village of Halfway with its own government and services. Within five years, it had grown to another level and became recognized by the residents and the State of Michigan as the City of East Detroit.

During the 20th century, the growing city initially attracted large numbers of hardworking immigrants and their increasing family members. Neighborhoods grew at a rapid pace, with a resulting increase in city services, schools, churches, and community groups.

The city had reached its maximum capacity for initial development by 1970. Outside events caused the city to change its course and redevelop. In the 1960s, a freeway system built along the eastern border stripped the city of the main transportation thoroughfare, resulting in a rapid deterioration of its main central business district. The placement of the so-called big-box stores of the 1980s and 1990s in an adjoining town transferred a great deal of shopping to the nearby malls. Still, many of the mom-and-pop businesses, which had started in the early part of the century, survived and influenced others with their business principles.

School enrollment dropped dramatically as household size decreased. The numbers of schools that had increased to accommodate students in the 1960s and 1970s dropped dramatically in the area with resulting school closures in modern times. Families pushed for college education for their kids, and often the college graduates moved to other cities or out of state to work in fields other than automotive.

Community values changed along the way. Church attendance dropped as individual values changed. Diversity changes and civil rights issues tested the backbone of the city. Women began to be seen in public offices as well as holding key positions in city and school administration. Still, the inherent community values persisted, and cultural assimilation occurred with little problem.

There was even a movement to change the name of the city. It took three elections and three different name options, but in the 1990s, the city name was changed to Eastpointe by a very slim margin.

Most of the aging residents preferred to stay in their homes rather than to move away from their friends and families. The city recognized the value of seniors and made efforts to accommodate

the increasing senior population. In the late 1960s, a large senior housing complex opened; other buildings for senior citizens opened in the 1980s and 1990s, with two more in the 21st century. What had been school property for the high enrollment numbers in the 1950s and 1960s was now being redeveloped into senior housing property.

Open parks and active recreation programs have always been part of the community life in East Detroit/Eastpointe. While baseball continues to be the mainstay of youth recreation programs, times have changed, bringing in things like roller blading and, of late, skateboarding. Still, the emphasis of the residents remains on quality, clean parks; picnic areas; and activities for youth and adults.

Eastpointe was one of the earliest communities to be hit with the modern recession. Residents working in automotive design, drafting, tool, and die were hit first with unemployment as production slowed. Others who worked on assembly or with suppliers were next to hit the unemployment list. Large numbers moved to other locations seeking employment, often leaving their homes behind.

Students who had acquired higher education and attained jobs in the fields of teaching, administrative work, technology, engineering, construction, and law were also hit hard. The real estate debacle that resulted from fraudulent mortgage practices had a huge impact on Eastpointe, as many people who had purchased homes on adjustable-rate mortgages could no longer keep up with the escalating mortgage payments.

Eastpointe made a large number of changes within its schools and city services. University extension programs provided assistance to prevent further foreclosures. Collaborative groups were formed with other cities to provide similar services. There was a huge emphasis with both groups to resize staffs and building numbers but still to maintain the core purpose. Major planning and zoning changes were made to help redevelop the city.

This collection of photographs depicts the story of how the city of Eastpointe survived the ups and down of modern times.

One

EASTPOINTE'S RAPID DEVELOPMENT

It can be safely said that Eastpointe's entire 5.2 square miles was 99 percent developed by 1960. To most that would mean that there were no pieces of vacant property available for new homes. The major thrust of this development occurred in the 12-year period between 1948 and 1960.

The population was rapidly changing. The postwar years brought dramatic increases in automotive production. Because southeast Michigan had been an arsenal of democracy, it was easier and less expensive to retool plants previously used for wartime manufacture than to build totally new factories. These factories brought in large numbers of former servicemen, and those servicemen were young marrieds looking for a good home for their families. Eastpointe's proximity to the factories made it a natural location for these workers.

The postwar years also brought in large numbers of immigrants also looking for new homes, safe neighborhoods, and good schools. The city of East Detroit offered all of those items. The immigrants became very involved with their churches and with neighborhood groups, and many remain well entrenched in their first and only homes, which were bought during that time period.

There were also many people who were living in Detroit's prewar flats who wanted to live in single-family dwellings with big yards. The developing city offered good streetcar and bus transportation back and forth to their jobs as well as neighborhood parks and schools for their kids.

The homes went up rapidly. Between 1952 and 1955, the number of permits to improve existing homes quadrupled in number. New homes increased from 800 in 1952 to 2,400 in 1954. By 1958, new home permits were down to less than 1,000 a year, as the golf courses and riding stables were the only properties left for subdividing. They too were sold to make way for new homes.

The ability for this rapid development to happen was actually because most of the water, drain, and sewer lines had all been put in place when the city was still a village. The development that was hoped for at that time did not come to fruition because of the Great Depression. The 1950s were a time of great opportunities for employment. Many of the servicemen were also able to use the GI Bill for college, which allowed for better-paying jobs. At the time, there was little concern about a repeat depression or massive unemployment.

All of the development was a huge challenge to the city councils and administration of that time period. The 1927 municipal building had become totally inadequate at handling all city services including police, fire, water, and the department of public works. But it was not just

city services residents were demanding. Altogether the residents and city council felt that new buildings were needed for city administrative services, as well as for recreation, a library, police, fire, water, and department of public works.

With the exception of the police department, all of those buildings were completed and opened between 1953 and 1955. (The police remained alone in the old municipal building until a new building was completed in the 1960s.) A combination of construction bonds, tax levies, and federal funds were used to finance these buildings, and all of them were completely paid for within two years of opening. Also, federal funds were used to buy two former farm properties for additional parks.

At the same time, the schools were forced to recognize the huge increase in school enrollment. Deerfield School was the first new elementary school to be developed, but soon, others were added on the west side of the city to take in the students who lived in Warren but attended East Detroit schools. Four more elementary schools were added on the east side of town. Oakwood and then Kelly Middle School were added as elementary-aged children grew, with additions to Grant School and several additions to East Detroit High.

To cope with the increase in population, seven new Catholic parishes were added, and so were two new Lutheran churches and multiple Protestant churches.

Business also developed along the main corridors of Gratiot Avenue and Eight and Nine Mile Roads, and a moderate amount developed along the south side of Ten Mile Road.

By 1969, the city of Eastpointe was fully developed.

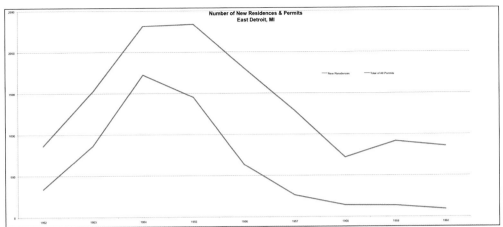

East Detroit's rapid growth can be seen easily by reviewing the number of building permits issued between 1952 and 1960. The growth of the city was further reflected in the doubling of population from 21,461 in 1950 to 45,920 in 1970. By 1978, there was a decline of about 3,500 persons due primarily to a decline in the birth rate, children moving away, and a number of college students transferring to different schools. (Courtesy of *The Halfway–East Detroit Story*, revised 1979.)

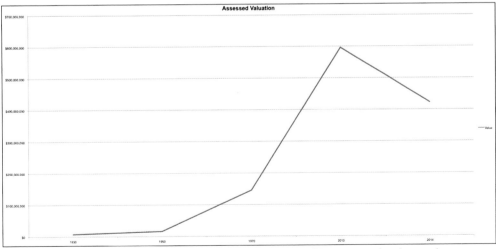

Changes in the assessed valuations for the city of East Detroit/Eastpointe also show a slow increase of assessed value from the beginning of the city in 1930 to a doubling of value from 1950 to 1970, as well as a precipitous drop in value from 2010 to 2014. (Courtesy of *The Halfway–East Detroit Story*, revised 1979.)

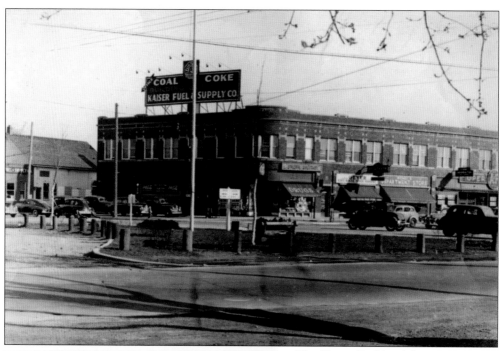

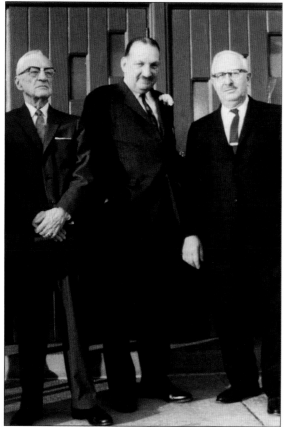

The Kaiser Building's basement was the location for all Village of Halfway, and later City of East Detroit, administrative services until 1927. This building also contained retail stores on the first floor and apartments, a dance floor, and banquet room facilities on the second floor. (Courtesy of East Detroit Historical Society.)

Joseph J. Wendt was one of the leading forces behind the major expansion of East Detroit. A former superintendent of Clintondale schools, he served on city council for 12 years. He lost a run for mayor by 17 votes but was reelected to council two years later. He pushed for a hospital in the South Macomb area, a solution to the drain problems, a full-time recreation director, and cooperation between officials and neighboring communities. He is seen here in the center with former mayor Christian Nill (left) and Bert Toll. (Courtesy of David Wendt.)

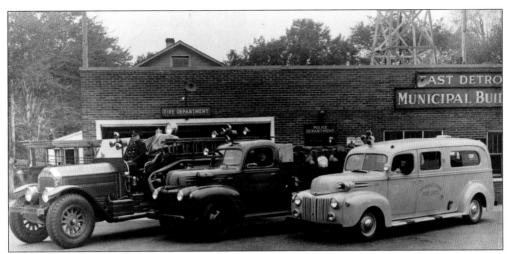

The East Detroit Municipal Building was located on Nine Mile Road, just east of Gratiot Avenue. Built in 1927, it housed all of the village, and later city, government departments until 1954. By that time, the population had reached 31,000, and this building had become extremely overcrowded and totally inadequate. (Courtesy of East Detroit Historical Society.)

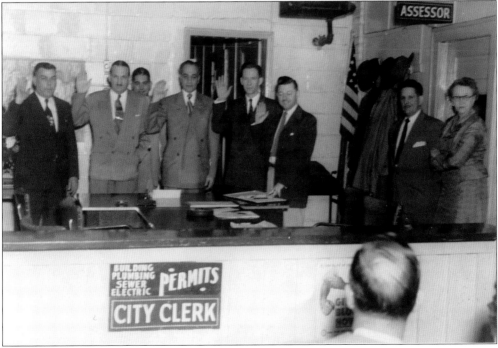

East Detroit's 1953 City Council is shown here as City Manager Charles Beaubien (on the right) swears them in. They are, from left to right, Constable Henry Hauss, Joseph Wendt, and Mayor Jim Anderson. On the far right are Councilman William Hudson and Councilwoman Beulah Kantner who were elected in 1952. Behind the council is former city councilman Carl Hollinger. City councils between 1948 and 1953 were able to use a combination of bonds, tax levies, and federal funds to build a new city hall, water, fire, library, recreation, and department of public works buildings. Each of these buildings was completely paid for by time of completion. (Courtesy of David Wendt.)

East Detroit City Hall was dedicated in October 1954. Built at a cost of $222,456, the building was designed to provide assessment, finance, building, clerk, and city manager services. An addition was completed within 20 years to the north side of the building at a cost of $81,000, paid for in full with federal revenue sharing funds. (Courtesy Partners in Architecture.)

City hall's back entrance was the most commonly used entrance. A large portion of the building doubled as the city council chambers and the municipal court. Probationary services and court officers were also housed here until a new court building was added in the late 1990s. This building was demolished after 50 years of service due to repeated roof problems, basement flooding, antiquated heating and cooling systems, and no access for modern informational technology. (Courtesy of Partners in Architecture.)

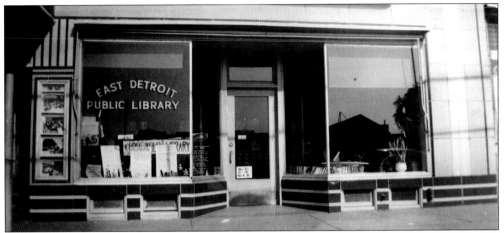

The old East Detroit Public Library was located in this storefront next to the East Detroit movie theater. Laughingly, people stated that the location was to increase the library patronage so residents would approve a tax levy for a new larger library. In 1953, the building on Oak Street was erected at a cost of $112,300, with a 3,000-square-foot addition in 1961 and a second 4,000-square-foot addition in 1971. It continues to be known as the cultural center of the city with multiple pieces of art and an increasing number of movies and lectures. (Courtesy of the East Detroit Historical Society.)

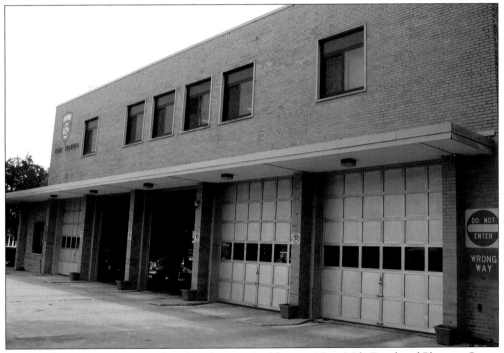

The fire department was transferred to this new building on Nine Mile Road and Pleasant Street in 1956. Located in the center of the city, the building was designed to give a quick response for emergency calls from all parts of the city. When it was opened, the department had what was considered to be the latest in firefighting equipment—two new American La France fire trucks, as well as a Ford fire truck, a Cadillac ambulance, a chief's car, inspector's station wagon, and utility truck. (Courtesy of Partners in Architecture.)

The department of public works was started in 1924 as a Village of Halfway function. It was housed in the Nine Mile Road Municipal Building until it moved to this new building on Ten Mile Road in 1952. (Courtesy of the East Detroit Historical Society.)

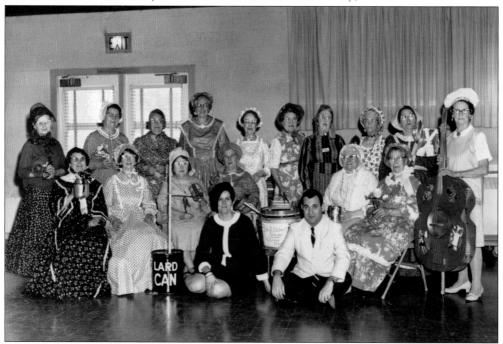

The Kitchen Band, seen here, was one of the first events at the new recreation center, opened on Stephens Drive, in 1955. The recreation center served a dual purpose as a location for meetings and senior activities during the day and teen activities in the evenings and on weekends. A later addition in the 1990s provided parks and recreation offices and additional meeting space for community groups. (Courtesy of the East Detroit Historical Society.)

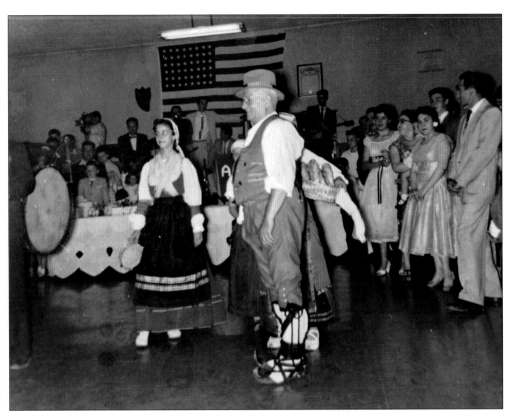

German dancers were brought in to instruct the children of the new residents about the customs and costumes of their homeland. Seen here are the Austrian dancers who were performing at St. Peter's. Church services were in German at both St. Peter's Lutheran Church as well as Immanuel Methodist Church until the late 1950s. (Courtesy of the East Detroit Historical Society.)

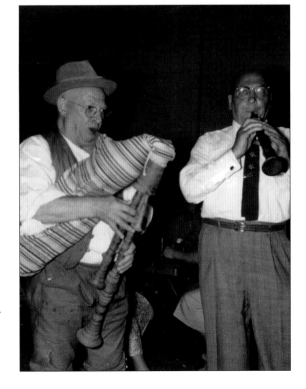

German bands often entertained local residents. Large numbers of German, Austrian, and Polish immigrants came to East Detroit between 1945 and 1960. Frequently, they staged musical events to rekindle friendships with great memories of the homeland. (Courtesy of the East Detroit Historical Society.)

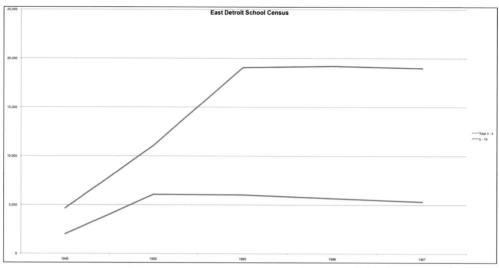

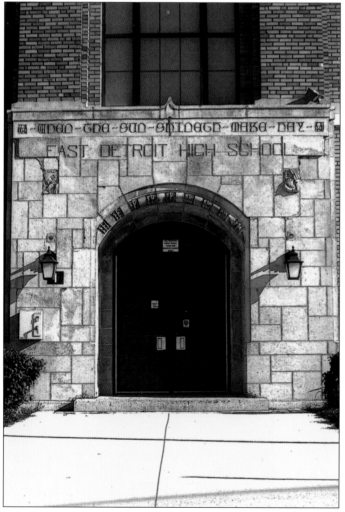

School census studies completed between 1945 and 1955 showed a rapid increase in the numbers of current and future students. By 1965, the picture was completely changed, with four times as many school-aged children as there had been in 1945. (Courtesy of *The Halfway–East Detroit Story*, revised 1979.)

East Detroit High School opened in 1932. By the 1950s, the high school was considered one of the most completely equipped schools in Michigan, consisting of a college prep program, business and technical curriculum, audiovisual facilities, a library, a vocational technical wing, and a special education complex. Two additions, including a swimming pool and new gym, were added in 1957, and in 1999, a field house was added to expand the physical education programs. (Courtesy of Marco Catalfio.)

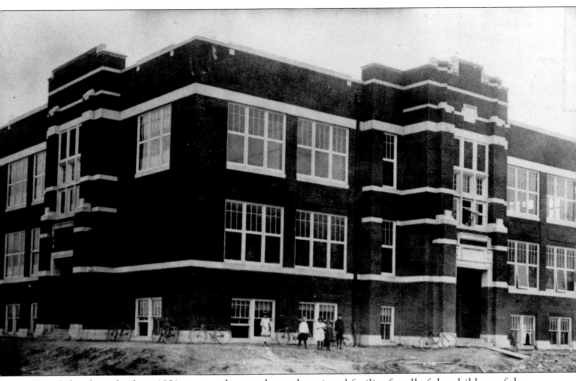

Erin School was built in 1921 to provide a modern educational facility for all of the children of the village of Halfway. It replaced the one-room schoolhouse, providing elementary-level classes. In addition, for the first time, high school classes were also provided for area students. Within 10 years, the huge increase in secondary enrollment forced the fledgling school district to plan for a new high school for the new city of East Detroit. (Courtesy of the East Detroit Historical Society.)

Oakwood Junior High was built in response to a dramatic increase of students in grades seven through twelve. In a school survey, 1,350 students were housed in a building that was intended to accommodate 800 students. Half-day classes prompted parents to become very verbal, insisting on a new school. A tract of land located between Nine Mile Road and Nehls Avenue was purchased for the new school, which opened in February 1953. (Courtesy of the East Detroit Historical Society.)

Oakwood Junior High was partially built on former Weinert farm property. In 2014, the Weinert family reunion took place in Eastpointe. Descendants visited their former family home, the school that had been built on the family's old farmland property, and the church where the family worshipped. They are seen here reviewing school records in the schoolhouse that their parents attended as children. Allyn Weinert was just 25 years old when he was elected mayor of Eastpointe in 1975. (Author's collection.)

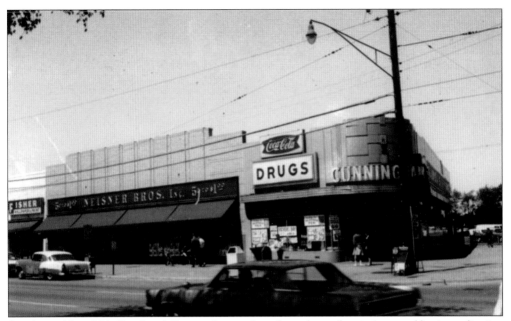

Southwest Nine Mile Road and Gratiot Avenue has always been the city's central business district. In the 1940s, the former Halfway Hotel was demolished to make way for this strip shopping center. Cunningham's Drugstore was the key store on the corner, followed by a Neisner Dime Store, and then smaller retail. Women cheered when Wrigley supermarket opened. The highlight of this shopping center was the free parking directly in front of the store. (Courtesy of the East Detroit Historical Society.)

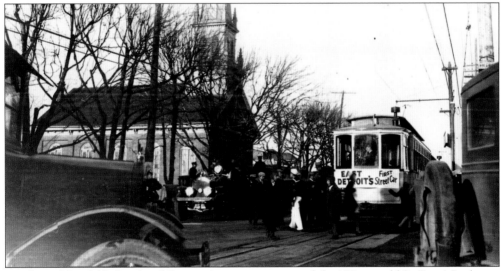

Northwest Nine Mile Road and Gratiot Avenue area retained the 100-year-old St. Peter's Lutheran Church and Cemetery until the early 1950s. By then, the growing congregation needed more space for a larger church, larger school, playground area, and additional parking. A decision was made to move everything down the block and to the opposite side of the street. This photograph shows how active Gratiot Avenue has always been at this corner, even back in the 1920s when the Detroit streetcar carried passengers between downtown Detroit and Ten Mile. (Courtesy of Jack Flath.)

Service organizations of every type have always been a major part of the East Detroit/Eastpointe community. These fraternal organizations provided opportunities for business networking as well as major fundraising and services for specific purposes. Up until the 1970s, the membership within these organizations was generally confined to males and often only to local business owners or politicians. Today they are open to both sexes. (Courtesy of the East Detroit Historical Society.)

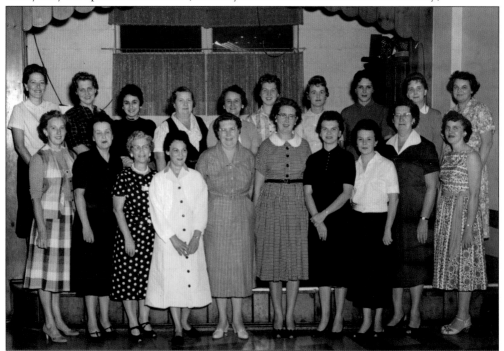

East Detroit's Metropolitan Auxiliary, later the Metropolitan Club Spirit, was organized in 1938 to promote friendship and to support charitable organizations. Membership was restricted to female employees of the police and fire departments and federal government and the wives, sisters, and widows of the male counterpart. Pictured are, from left to right, (first row) M. Conte, A. Holland, E. Kitzmiller, E. Voakes, E. Redmun, R. Krueger, A. Weishaupt, D. Holland, R. Bauer, and M. Sherman; (second row) A. Lemke, H. Heins, M. Edwards, R. Beske, M. Rinke, J. Dubin, E. Oke, M. Fox, M. Gilbert, and A. Molnar. (Courtesy of the East Detroit Historical Society.)

Two

ASSERTION OF A
COMMUNITY CULTURE

Reviewing historical times often changes the direction of current and future events. It may take a number of years, but history generally repeats itself.

In 1975, plans began across the United States to celebrate the US Bicentennial. Representatives from the national committee fanned out to work with local communities. Their primary goal was to assist in the planning of events for a nine-month period that would tell the story of how the US became independent and to provide backup information to local communities as needed. Activities would culminate with a major event on July 4, 1976.

The secondary goal of the Bicentennial was to assist local communities in discovering, recording, and preserving their own history. If a city did not have a historical society, the Bicentennial representatives would also assist with the establishment of that group.

In East Detroit, librarian Alma Howard was chosen to lead the Bicentennial committee. The library itself was designated as the cultural center. On the advice of the consultant, the committee membership included school and city representatives as well as local residents. Various service organizations, such as Girl Scouts, Boy Scouts, and Veterans of Foreign Wars (VFW), were also involved. As a result, several projects were developed to highlight the US Bicentennial and local history, like the Girl Scout project that developed a slogan for bumper stickers and a VFW project that designed, painted, and built a Bicentennial gazebo now located in Kennedy Park.

First-person histories of many of the longtime residents were recorded. Their memories of what community life was like in the early days often brought forth information that was previously unknown. Having city and school representatives on the committee brought a new aspect related to city and schools that had never been recorded. That led to an updated revision of Robert Christenson's book, *The Halfway–East Detroit Story.* An audiovisual consultant, who was completely unfamiliar with the local city, recorded the city in photographs in 1976.

The end result was that people began to see their community foundation through different-colored glasses. They realized that their community had its own special culture. The Bicentennial also helped citizens take note of what the community then currently had to offer, like its buildings, school system, and cultural diversity.

At the time of the Bicentennial, baseball remained as one of the favorite pastimes. If one were too old to play, he or she was out watching the younger people or the Detroit Tigers play. It was a

great time for all when the new Tigers owner Mike Ilitch brought his professional softball league to play ball at Memorial Field. Everyone, it seemed, was involved with picnics, dances, concerts and festivals.

The community was very involved with the political process at the school board and city council levels, as well as with state legislature and Congress. Those running for city offices often numbered 10 or more. The percentage of voters often exceeded 20 percent.

Everyone seemed to recognize and cultivate what continues to be the backbone of the community—the youth. Youth baseball and football leagues were always filled with multiple age-levels of teams. Scouting programs were existent at every school. Church youth programs never lacked special activities for teens. Extracurricular activities at the high school were always well attended. Continuing education was well attended.

Eastpointe's community foundation was solid. It was founded as the village of Halfway was formed and would continue to survive in the future.

A Bicentennial planner from Macomb County came to assist community leaders as they developed a committee, which would then plan nine months of events celebrating American and local history. Seen here is East Detroit's librarian Alma Howard, who was chosen to head the Bicentennial committee. Media specialist Gerald Gazda was in charge of documenting local history. (Courtesy of the Eastpointe Memorial Library.)

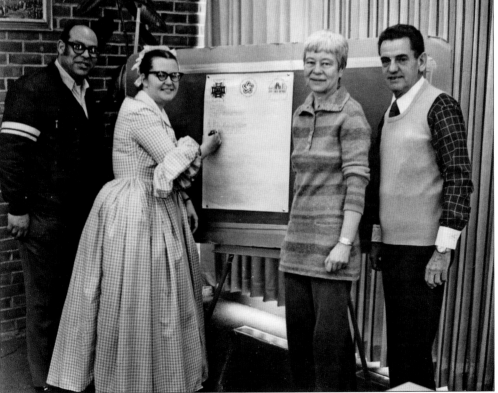

The Bicentennial committee, established in 1975, was quick to recognize the need to establish a group to preserve local history. Seen here are committee members at an early planning meeting. They are, from left to right, Councilman Joe Portelli, Sandra Gray, librarian Alma Howard, and Robert Pilkey. (Courtesy of the East Detroit Historical Society.)

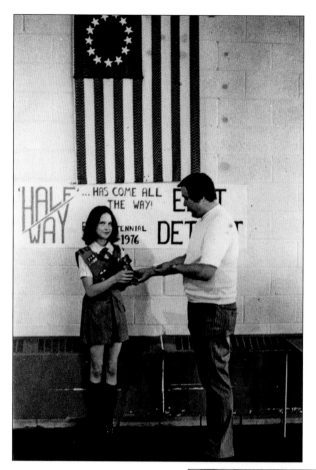

The Bicentennial committee gave East Detroit Girl Scouts the task of creating a slogan pertaining to East Detroit's local history that could be used for promotion of local events. Prizes were given on Youth Day at the East Detroit Teen Center to all four levels of participating Girl Scouts. (Courtesy of the East Detroit Historical Society.)

"Halfway . . . has come all the way" was the winning slogan in the city's bumper sticker contest sponsored by the Bicentennial committee. Sharlene Kluchinsky from Girl Scout Troop No. 204 was the top winner with the slogan and design. More than 70 East Detroit Girl Scouts submitted entries. Honorable mentions went to Cheryl Cain, Dawne Quenneville, and Cheryl DeCroix. Sharlene received a ceramic Liberty Bell bank, a silver dollar, and a charm. (Courtesy of the East Detroit Historical Society.)

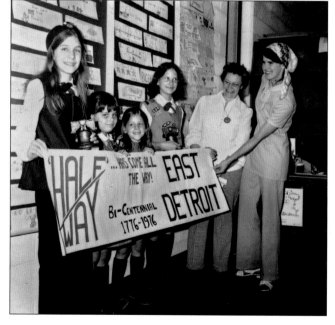

Mark Logsdon was the founder and conductor of Macomb County's Colonial Fife and Drum Corps. An East Detroit High graduate, Mark was a music teacher who undertook extensive travel and research in an effort to assure authenticity in his reenactment of the colonial music. He is shown here with Macomb County commissioner Herbert McHenry as he introduces the first of the Bicentennial programs presented over a nine-month-long celebration. (Courtesy of the East Detroit Historical Society.)

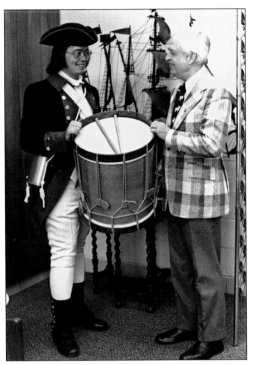

The Colonial Fife and Drum Corps, seen here, was made up of students from St. Barnabas Grade School. As part of the Bicentennial celebration, they trained under the guidance of Mark Logsdon. The music, instruments, and clothing were exact reproductions of those of the Revolutionary period. They are seen here as they marched from their school to city hall to start the celebrations. (Courtesy of the East Detroit Historical Society)

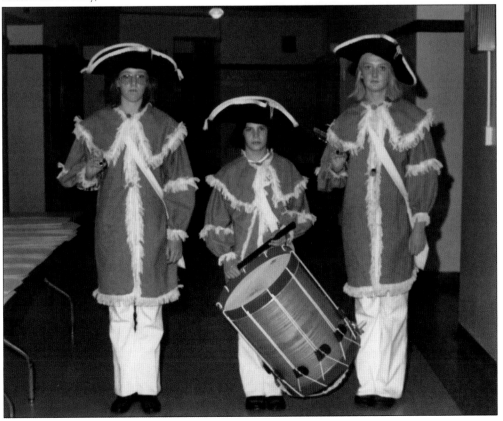

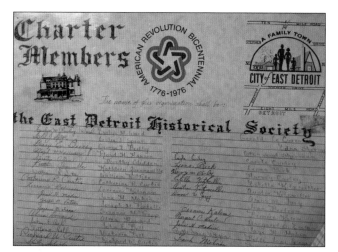

The East Detroit Historical Society charter was signed by 60 people in 1976. Most of these residents had served on the Bicentennial committee and realized the lack of documentation of local history. They affixed their signatures to the charter at the initial meeting of the historical society, held in the library. At the same meeting, a slide presentation by William Tite was given on the historic homes of East Detroit. (Courtesy of the East Detroit Historical Society.)

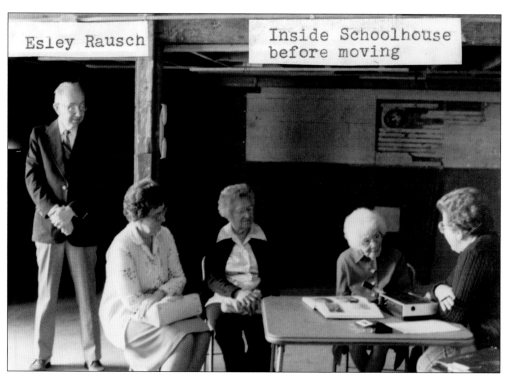

Members of the East Detroit Historical Society recorded oral histories of senior citizens, business owners, and school officials. These recordings documented 150 years of life in the village of Halfway and the city of East Detroit. In 1976, retired principal Carol Bratt and retired East Detroit finance director Esley Rausch updated and revised the only history book ever written about East Detroit, *The Halfway–East Detroit Story*. (Courtesy of the East Detroit Historical Society.)

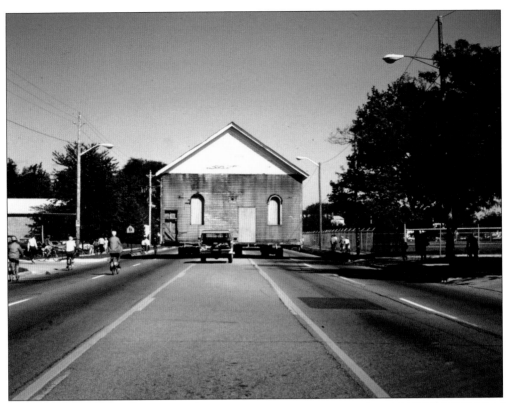

Moving the 1872 schoolhouse was also a result of the Bicentennial celebration. Multiple oral histories noted that the old schoolhouse remained in the city and was being used as a storeroom. Planning began to move it back to its original location. The schoolhouse is seen here as it inched its way down Nine Mile Road to its current location near the high school. (Courtesy of the East Detroit Historical Society.)

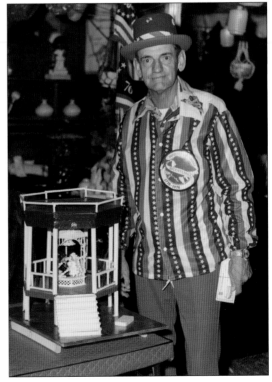

The Kennedy Park gazebo was another Bicentennial project. Chaired by Robert Pilkey, the VFW Post No. 6782 designed, built, and painted the red, white, and blue gazebo to be used as a grandstand for band concerts, weddings, and Memorial Day ceremonies. It was dedicated on July 3, 1976, with a wedding performed by Mayor Allyn Weinert, followed by a box social with lunches made by local women for single men. (Courtesy of the East Detroit Historical Society.)

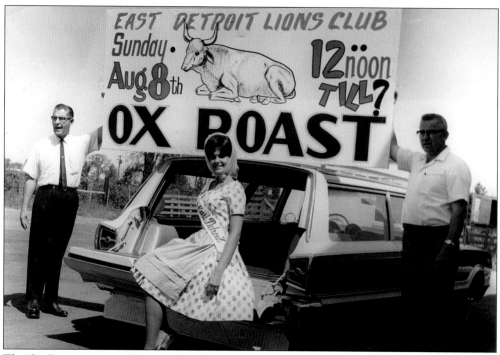

The Ox Roast, sponsored by the East Detroit Lions Club, was instituted in the 1940s. Initially, it was called "Meet Your Neighbor," representing a way to bring the community out to meet their friends and neighbors. Various musical groups would entertain. Carnival rides and vendors were brought to provide amusement to all. The highlight of the weekend was often when Miss East Detroit was crowned. Over the years, it became the city's major summer event. (Courtesy of Eastpointe Lions Club.)

The Lions Ox Roast name was given to the event in the 1950s, when an ox was actually roasted. The roasting of the ox started the night before with an ox large enough to supply meat for the entire weekend. A change in the board of health rules stopped the roasting of an actual ox, but the Ox Roast name continued for another 40 years, even though the menu changed to corned beef, sausages, and chicken. (Courtesy of Eastpointe Lions Club.)

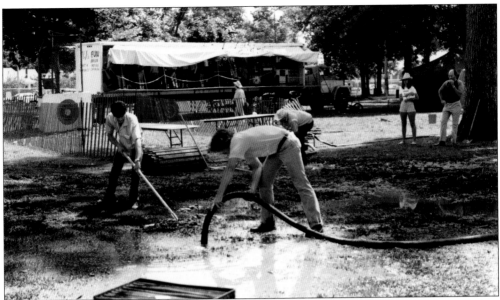

The Ox Roast was held annually in August, which is often prone to heavy rains. In the early days of East Detroit, the area now known as Kennedy Park had been a swamp. Though efforts were made to drain it for the park, those heavy August rains frequently leave the park under inches of water. Lions members are seen here during one of the frequent times they had to drain the park before—and often during—the event. (Courtesy of Eastpointe Lions Club.)

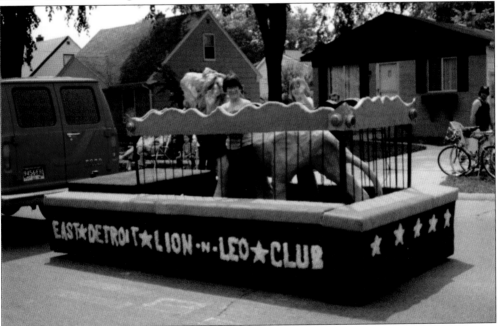

The Leos are the youth version of the International Lions. Multiple activities are provided for the teens to be involved in services to the blind, working with Leader Dogs to provide service dogs for the blind, and providing assistance at Lions events. They are seen here participating in the Memorial Day parade, which has always been a large community event in Eastpointe. (Courtesy of Lion Paul Hemeryck.)

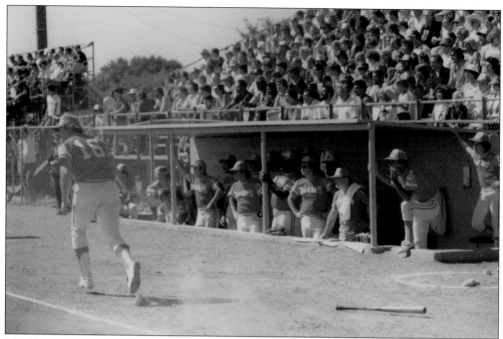

The Detroit Caesars began to play at Eastpointe's Memorial Park in the late 1970s. The team's owner, Mike Ilitch, had formed a team named after his pizza company, Little Caesars. As part of the semiprofessional fast-pitch softball league, the team played competitively with teams from all across the country. (Courtesy of Ilitch Holdings.)

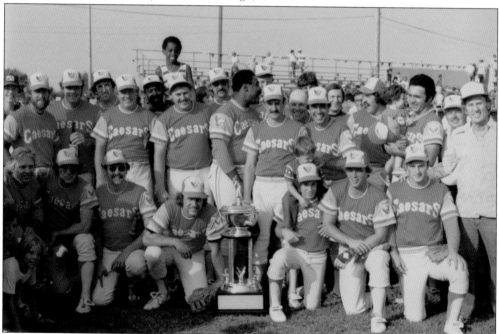

With former players from the Detroit Tiger franchise, it was not too difficult to have a winning team. Pictured here is one of the trophy-winning teams. Owner Mike Ilitch is seen on the right. (Courtesy of Ilitch Holdings.)

The grandstands were always filled with people wanting to watch the Caesars play at Memorial Field. It was said that the park held thousands of eager baseball fans who came to watch the tough competition. Occasionally, entertainers also performed. A favorite was local comedian Soupy Sales. (Courtesy of Ilitch Holdings.)

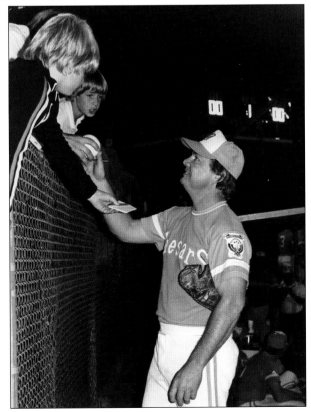

Norm Cash played with the Caesars following his retirement from the Detroit Tigers. Baseball in East Detroit was the major pastime for all. If a person was not playing, he was watching the game. It was a thrill for all to be able to watch major-league heroes, such as Cash, play on local diamonds. It was even more exciting to shake their hands and get an autograph. (Courtesy of Ilitch Holdings.)

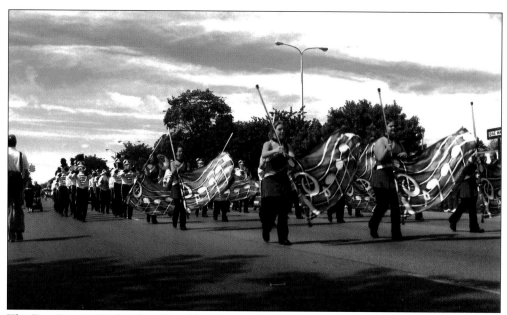

The East Detroit High School band has been a tradition since the high school opened in 1932. Music education begins in the elementary grades, with some advancing to instrumental and band in middle school and high school levels. Pictured here in recent times is the marching band during a Memorial Day parade. (Courtesy of Sue Young.)

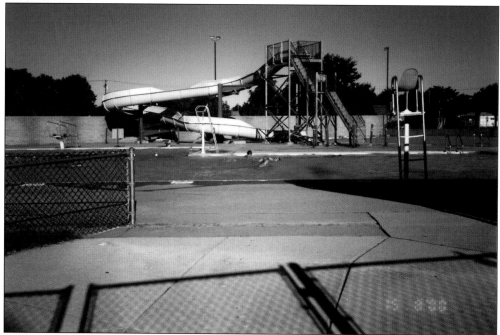

The Kennedy Park Swimming Pool and Bathhouse complex is pictured here. Although a swimming pool was the goal of every city council since the 1950s, an outdoor swimming pool never became reality until this pool was built in 1967. Voters wanted the pool so badly that they voted for two special tax levies in two successive years to pay the cost of $425,734. At the time of completion, it was the only city location for swimming lessons. (Courtesy of Sue Young.)

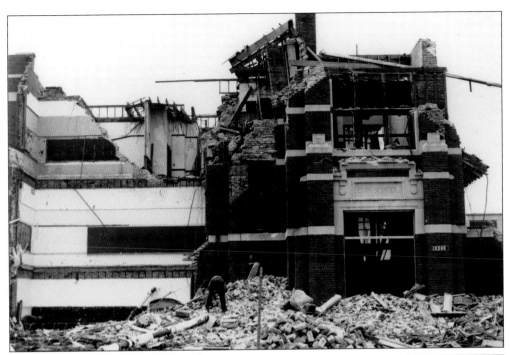

It was a sad day for many former students when Erin, the first area grade and high school, was demolished. By that time, the maintenance on an old building was prohibitive. East Detroit High had opened, as well as Grant and Oakwood Junior High Schools. In addition, three new elementary schools were added in areas where large numbers of students resided. (Courtesy of the East Detroit Historical Society.)

As the East Detroit Historical Society began preparation for the restoration of the old schoolhouse, many former students came forward to record their memories. Eleanor and Ed Lorenz brought this photograph they had kept for over 50 years. Seen here are Mrs. Morris, who taught history, and Miss Baylor, who taught English. Both were beloved teachers who taught the first Erin High School classes. (Courtesy of the East Detroit Historical Society.)

St. Veronica Catholic Church had expanded the church buildings and school several times by the late 1950s. In order to cope with the rapidly increasing number of Catholics, two new parishes were added inside the 5.2-mile city limits, and an additional three more churches were built right on the city borders. Each church also had a large parochial school for grades one through eight. (Courtesy of Sue Young.)

St. Peter's Lutheran Church also increased in size to cope with the increasing numbers within its congregation as large numbers of German Lutherans immigrated to the United States in the postwar years. St. Thomas Lutheran Church also moved into the rapidly growing area, providing members of a different Lutheran synod with a place of worship and a private school. (Courtesy of Marco Catalfio.)

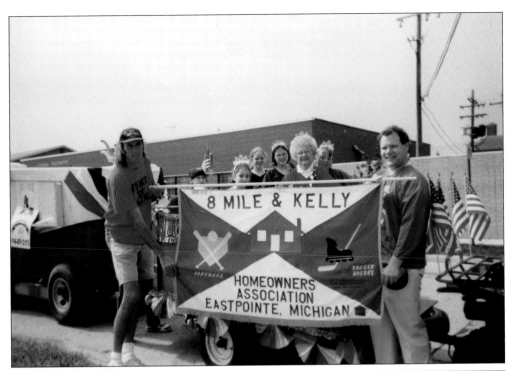

The Eight Mile Kelly Homeowners Club was the largest of three different homeowners groups that emerged in the 1950s. Each of the three provided opportunities for information on city and school issues as well as dances, dinners, picnics and recreation for the children. Group members Bob Smith (left) and Tom McCauley are shown during a Memorial Day parade holding a banner taken into space by Eastpointe native astronaut Jerry Linenger. (Courtesy of Sue Young.)

Picnics and festivals were part of the homeowner's summer fun. Pictured here is city councilman Jim Kelly as he grills sausages, onions, and peppers at one of the roller hockey fundraisers. Jim served on several city commissions as well as city council and as mayor pro tem. He is currently the chairman of the Macomb County Community College Board of Trustees. (Courtesy of Sue Young.)

Leo LaLonde is a longtime East Detroit resident who received overwhelming support when he ran for the Michigan State House, representing East Detroit. He is shown here in a local parade with his niece. Also in the car are East Detroit mayor Joe Portelli and Mayor Pro Tem Joyce Phillipi. (Courtesy Leo LaLonde.)

Leo LaLonde was considered a state representative who represented his constituency well. He is seen here in Lansing with East Detroit City Council members as the governor signed East Detroit–requested legislation clearing confusion about the types of weapons police could carry in their cars. Leo later worked for the Michigan Department of Prisons until he retired. (Courtesy of Leo LaLonde)

Sen. Gil di Nello was a local resident who was elected to the Michigan Senate following service at the Michigan State House of Representatives. He served in the senate at the same time as Leo LaLonde served in the house. Unusual as this was, it also attests to the political involvement and support local residents had with government decisions made both at local and state levels. (Courtesy of Leo LaLonde.)

Ed Bonior was first elected to East Detroit City Council in 1958 and was elected mayor in 1963. He led the campaign as he focused on issues related to safeguarding water resources, eliminating flooded basements, and increasing recreation opportunities. His son Dave, seen here in the center with another son, Jeff, stood for many of the same issues when he served in the US Congress from 1976 to 2002. (Courtesy of Leo LaLonde.)

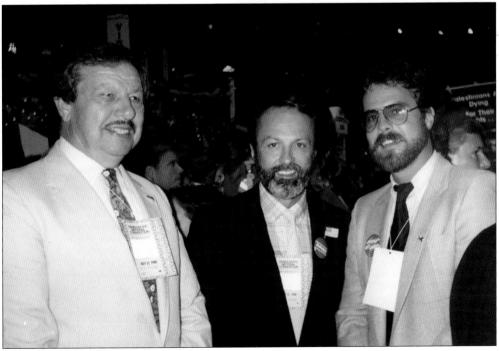

Bill Mihelich was one of the most popular mayors of the East Detroit era. A graduate of a Pennsylvania agricultural school, he rapidly became a successful businessman as owner of Mihelich Nurseries. He served as president of the East Detroit Chamber of Commerce and, later, as president of the East Detroit Lions. He died at a young age while still in office. Joyce Phillipi assumed his role as mayor pro tem for the remainder of his term but was defeated in her bid for mayor by fellow councilman Joe Portelli. (Courtesy of the City of Eastpointe.)

Boy Scout troops have always been sponsored by the East Detroit Lions Club. It is never surprising to see Scouts marching with them in the parade or working with Lions members at community events. They can be seen here assisting in the kitchen at the traditional Sunday morning pancake breakfast during the annual Ox Roast. (Courtesy of Eastpointe Lions Club.)

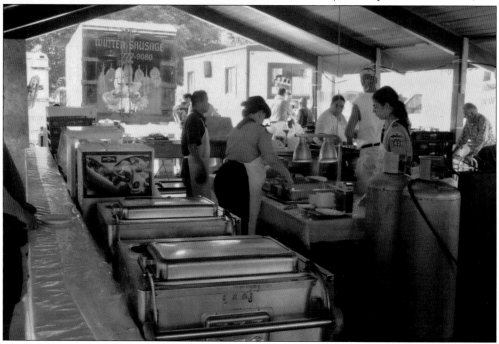

Three

EMERGENCE OF DIVERSITY

With the large population influx of the late 1940s and 1950s, noticeable changes within the community became evident. Open spaces soon became filled with subdivisions full of so-called cookie-cutter homes. Gravel streets became paved. The family gardens that formerly filled vacant properties were now filled with new homes. Sandlot baseball became a thing of the past. Skating rinks became buildings. Riding stables and golf courses became new developments. School buses became a thing of the past, since there were new schools within walking distance. All of these changes to the established norm often came with some degree of resistance from the established community.

Diversity also became evident. With large numbers of immigrants moving in, English suddenly was not the only spoken language. Italian, Polish, and Slovakian replaced the German, French, or Dutch languages previously heard in restaurants and public places. Teachers and students alike had to make the adjustments.

Religions became more diverse. As people moved in from the South, there was suddenly an increase in Protestant churches. Their youth groups attracted teens. With the large influx of immigrants from Eastern Europe, there was suddenly a huge increase in the number of Catholics. In time, all these changes were accepted by the local community without problem.

Values changed as women took a more active role in the workplace. It became commonplace for women to run for political office on either the school board or city council. Their ability to run their homes prepared them well to run local government. Adult education classes were frequently filled with stay-at-home moms who were motivated to expand their knowledge. As the children grew older, women craved jobs in the workplace. Starting in the 1950s, evening classes were offered at the new Macomb Community College.

The civil rights movements of the 1960s and 1970s had some effect on the local population. John Kennedy was a hero to most within the area, and his words, "Let us set aside differences," began a local move to gain a better understanding of other cultures, bringing together friends and neighbors. Open invitations were extended for international festivals, citywide picnics, and dances. Homeowners groups flourished.

The African American population within the Eastpointe area was a very low percentage well into the 1980s. Since that time, that population percentage has increased with little problem with integration. That overall general acceptance might come from the traditional acceptance of all people, regardless of the ethnicity. For the most part, those moving in have been Detroiters looking for a clean neighborhood, good schools, and a safe place for their kids.

In the late 1990s, a group known as PACE (Police and Community for Equality), which included city, school, and business leaders, was started to discuss issues that could lead to a diversity problem.

Discussions within PACE led to the establishment of a volunteer public safety chaplaincy program. With chaplains riding with police, a number of issues related to the possibility of racial profiling were reduced. This exemplary program has now led to the Public Safety Chaplain Academy, established at Macomb Community College, which has been replicated throughout the state.

Modern times, with increasing economic stress, working single-parent homes, and parental stress have often led to teens needing a safe place to go. They often are in need of mentoring and counseling. Several youth groups have developed within the local churches, and the Eastside Teen Outreach stands out among these groups. Accolades continue to support the group's founders, Deena and Doug Trocino, as the group numbers and goals change with the times.

The following chapter gives the reader some views into Eastpointe's diversity.

Mildred Stark was not only the first female to be elected mayor in East Detroit but also the first female mayor in the state of Michigan. She served a total of six years before becoming the first female Macomb County commissioner. She was a tenacious visionary with a legal background; she was not afraid of taking the controversial route if it improved the city and residents. Under her leadership, a troublesome amusement park was eliminated, five new city buildings were completed, debt was restructured and reduced, and plans were initiated to eliminate flooded basements. (Courtesy City of Eastpointe.)

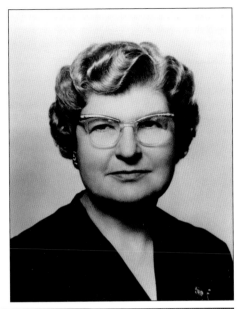

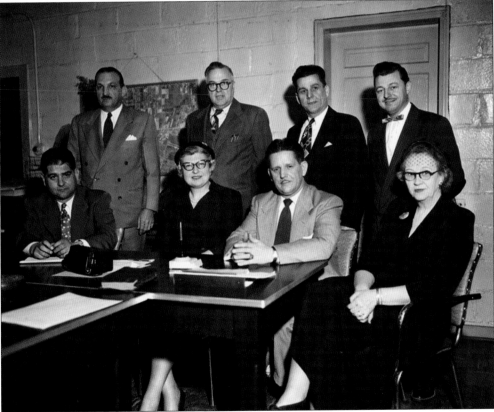

Beulah Kantner (far right) was the second woman elected to Eastpointe City Council. Though she was the widow of superintendent of schools John Kantner, she had been a teacher for 12 years before her election to council. She was known to be tough on spending and a huge proponent for recreation for kids and teens. (Courtesy of David Wendt.)

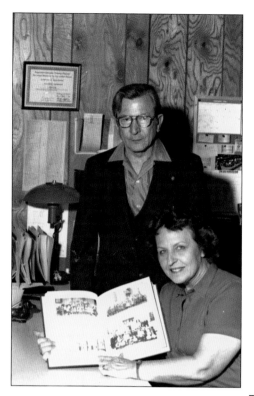

Ruth Cain was a member of the Bicentennial committee and was also active in civic and church activities. It was her determination to document and preserve local history that led to the formation of the historical society. She died at an early age and was recognized with the East Detroit Citizen of the Year Award posthumously during the Michigan Week Banquet in 1986. She was also given the highest award in Girl Scouting, the Lamb Award. (Courtesy of the East Detroit Historical Society.)

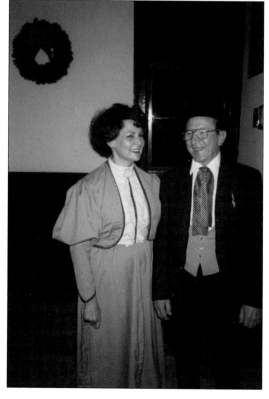

Meg Humes is another strong female who served on the board of education for 13 years, often as the lone female. She followed the footsteps of Mabel Beckstrom, who was elected to the board during World War II. Both women were mothers who pushed for full-day schools, improved buildings, a strong school curriculum, and extracurricular activities. Meg is shown here with retired fire chief Frank Molnar as they celebrated a 50th anniversary of the high school. (Courtesy of the East Detroit Historical Society.)

Colleen Cohan was a health-care attorney who was elected to Eastpointe City Council with the hopes of reducing expenditures and improving neighborhoods and community involvement. She is seen here during a historical reenactment event dressed as her Irish great-grandmother Elizabeth Cohan. Her great-grandmother had leased a Corktown shop from Henry Ford that was later moved to Greenfield Village. Colleen is seen here with Jim Winn, dressed to portray Henry Ford driving a Model A. (Courtesy of Sue Young.)

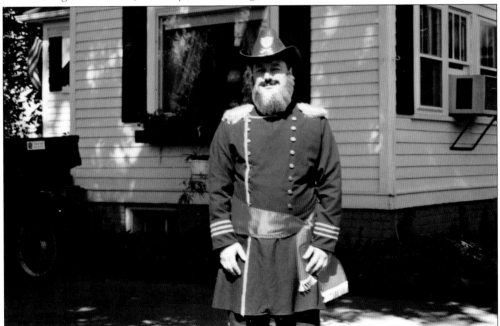

Former mayor Frank Accavitti was serving in the Michigan legislature when he returned to Eastpointe to participate in the historical society's garden party. When attendees were asked to dress as their favorite historical figure, Frank came dressed as Gen. Ulysses S. Grant, who led large numbers of Michigan troops during the Civil War. (Courtesy of Sue Young.)

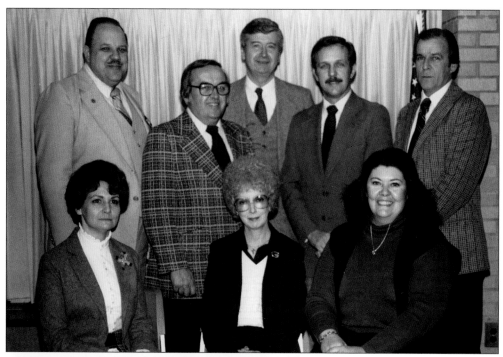

The 1981 East Detroit School Board was confronted with many difficult issues related to dwindling enrollment and too many school buildings. It was this board that voted to close and sell the historical Grant School, which meant that many east-side students had to attend a school as far as two miles away. Seen here are, from left to right, (first row) Meg Humes, Corrine Harper, and Cecilia DiPofi; (second row) David Appelt, Gene Kaminski, superintendent of schools Dr. Louis Christensen, Harvey Curley, and Danny Ouellette. (Courtesy of Harvey Curley.)

Corrinne Harper was first elected to the East Detroit School Board in 1978. She was always known as a practical person when it came to tough decisions. She and fellow board member Harvey Curley survived a recall election over the Grant School closing but were both defeated in the next election. Corrine was reelected a few years later and served on the board for a total of 18 years. Harvey was elected to city council and, later, as mayor. (Courtesy of Sue Young.)

The Goodfellow Fund of Detroit began in the early 1920s when former newsboys, city officials, and employees would stand on corners selling special editions of the local newspaper. The funds raised were used to purchase toys so no kid in the city was without a toy at Christmas. The tradition continues today with the fire department managing the paper design, sales, and toy delivery. Pat Mann is seen here on his corner, dressed for the Michigan winter that usually hits on the December weekend of the Goodfellows' paper sale. (Courtesy of Sue Young.)

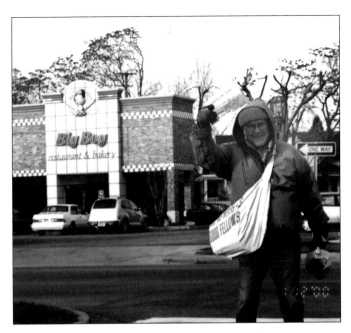

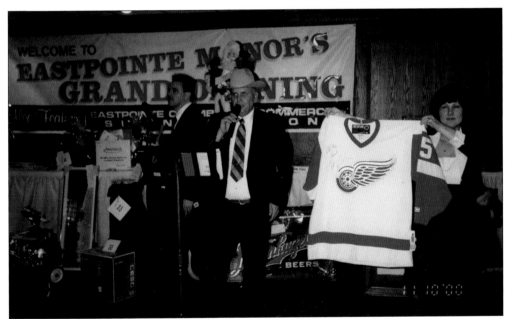

The Eastpointe Chamber of Commerce Charity Auction began in 2000 as a means for businesses to help support local charities. Donations are being auctioned off in this picture, with bids coming in from the floor. The items that bring in the highest amounts are usually the ride on the fire department's ladder truck followed by a chief's pancake breakfast, a ride in a police car with lunch with the police chief, or a day with the city manager. The first annual event, seen here, also marked the grand opening of the new banquet hall—the Eastpointe Manor. (Courtesy of Eastpointe-Roseville Chamber of Commerce.)

City Manager Wes McAllister came to Eastpointe with a vision for creative redevelopment. He followed Steve Banchak, who had initiated planning studies to update the central business district at Nine Mile Road and Gratiot Avenue. Within 12 years, a downtown district was created, two new senior housing buildings were in place, cooperation with surrounding communities had been reestablished, every firefighter had Advanced Cardiovascular Life Support (ACLS) training, and the city had a new ladder fire truck. His administrative team won accolades, and his peers personally honored McAllister as one of the most outstanding city managers. (Courtesy of Sue Young.)

Paula Holtz (left) and Leslie Beswick (right) were hired by Wes McAllister to be part of his administrative team. Leslie assumed the role as assistant city manager with a responsibility for deputy clerk and purchasing. Paula was chosen to replace Michelle Hodges as the director of the downtown development authority and director of economic development. (Courtesy of Eastpointe-Roseville Chamber of Commerce.)

Michelle Hodges was only 17 when she was crowned Miss East Detroit. Following graduation from Michigan State University, she returned to her hometown to assume the position as director of the downtown development authority and economic development director. She was very involved with the planning of the redevelopment of the Nine Mile Road–Gratiot Avenue area, the creation of the Eight Mile Boulevard Association, and the implementation of the city's name change to Eastpointe. (Courtesy of Sue Young.)

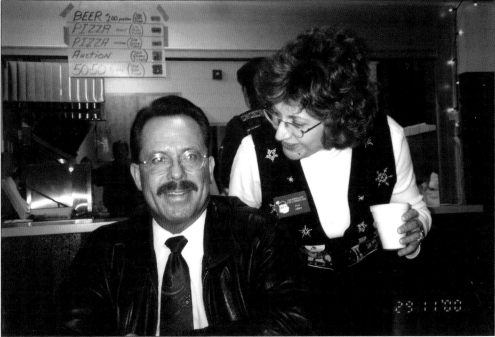

The new Eastpointe City Council of 2000 hired Wayne O'Neal. Like Wes before him, he was very involved with the community, worked diligently with water and infrastructure, and established a management-by-objective system. He is seen here with councilwoman Flo Abke at one of the State of the City luncheons. (Courtesy of Sue Young.)

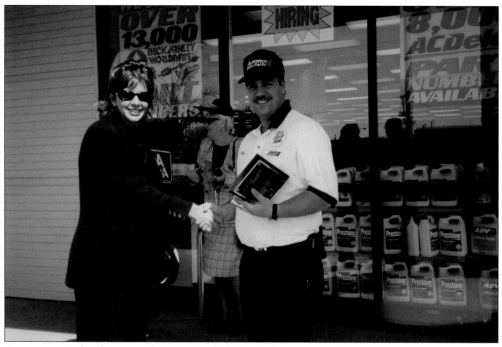

As economic development director, Paula Holtz's main responsibility was to market potential openings for retail development. She was also involved in working with established businesses to resolve building problems, assist with marketing, and to work with the building department and the planning and zoning commissions. (Courtesy of Eastpointe-Roseville Chamber of Commerce.)

At a Michigan Week ceremony, Paula Holtz was recognized for her assistance with the East Detroit Chamber of Commerce business members. She is seen here receiving the You Made a Difference Award from the president of the chamber of commerce, Jerry Luck. (Courtesy of Eastpointe-Roseville Chamber of Commerce.)

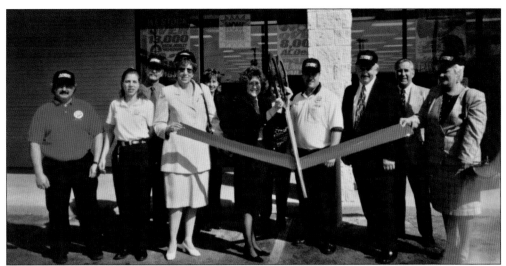

A ribbon-cutting ceremony marks a new business coming to town. For the economic development director, as well as for the local chamber of commerce, it is always a positive sign. At the time of this photograph, there was a female economic director, a city councilwoman, and a female president of the local chamber of commerce. They are pictured at a car parts store. Here, Paula Holtz (left) shares the honors with Councilwoman Flo Abke. (Courtesy of Eastpointe-Roseville Chamber of Commerce.)

Flo Abke was an East Detroit city councilwoman when she sponsored this team of teens who called their roller hockey team the Hot Shots. With a great deal of effort from the roller hockey program director Jay Brown and their individual coaches, the team went to Florida for national competition, bringing back trophies and great smiles. (Courtesy of Jay Brown.)

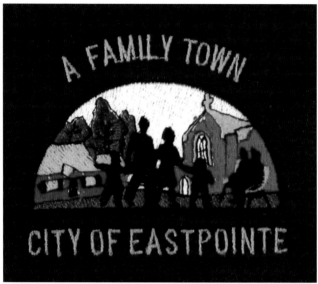

The city logo, developed during the Bicentennial, was just one of the changes that happened when the city's name changed to Eastpointe. With very little industry in the city's borders, the city had developed a reputation as a safe place to raise kids—a family town. The team that developed the logo wanted to include the historical churches. Although there have been attempts to change it, the residents firmly overrule any possible name changes, and the logo continues to remain as strong as it was the day it was unveiled. (Courtesy of East Detroit Historical Society.)

Drawing from the radio experience gained while running a US Air Force radio show in Saudi Arabia, Mayor Harvey Curley began a monthly show on the city's cable channel. During one of these, he was called to talk about the presence of churches on the city's logo. A Detroit radio show picked up on it, raising civil rights issues. Harvey interviewed with the nationally syndicated radio show, and before any time at all, calls came in from all over the United States in support of Eastpointe's logo. (Courtesy of Harvey Curley.)

Moms' broom hockey was a game invented by the Eight Mile Kelly Mothers as a spoof on their kids' interest in ice or roller hockey. The moms played on the same rink, but wore tennis shoes instead of skates and used balls instead of hockey pucks and brooms as hockey sticks. They seemed to make up new rules as they played, providing laughs for all. (Courtesy of Sue Young.)

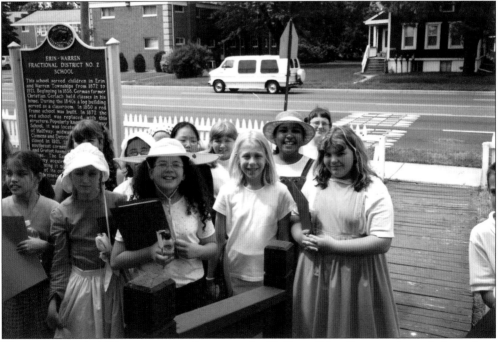

Elementary-aged children return each year to the Halfway Schoolhouse, where their teachers take them back in time. Pictured here are Bellview schoolteacher Sharon Eccles and her class as they wait for the school bell to welcome them into the one-room schoolhouse. There, she will conduct the class as the teacher did in 1872, as a single teacher with students from eight grades. On their recess hour, students will partake in 19th-century games. (Author's collection.)

The Eastpointe Chili Cook Off was started by the Eastpointe Networking Forum as a means of getting people out of the house in the winter. Police, fire, schools, city employees, and service organizations each made a different chili recipe and their decorated booths. The 1950s, shown here, was the winning theme developed by the teens of the Eastside Teen Outreach group. (Author's Collection.)

The Eastside Teen Outreach group was started when Deena and Doug Trocino noticed an increasing number of teens coming to their home, needing a place to go and someone to talk to. Over 160 teens are now a part of the Eastside Teen Outreach. The Trocinos are seen here receiving Congressional recognition during the PACE annual Christmas luncheon. (Author's collection.)

In 2006, Eastpointe police chief Mike Lauretti initiated a volunteer public safety chaplaincy program. After completion of police reserve training, chaplains ride with the police on busy nights, assisting as necessary. What started in Eastpointe has now developed to a basic and advanced public safety chaplaincy program taught at the Public Safety Academy at Macomb Community College. Chaplain James Friedman is seen here with Sen. Steve Bieda (center), Mayor Suzanne Pixley, and Mindy Albright as the Michigan Senate recognized Public Safety Chaplain Day. In the back row are an unidentified Warren resident and Chaplain Don Yorcs. (Courtesy of Michigan State senator Steve Bieda.)

Legends is one of Eastpointe's restaurants that provide foods specific to an international culture. A native of Albania, Lon Heshaj came to the United States with an idea of highlighting not only his native foods but also his interest in Hollywood legends. He is seen here receiving an award for Christmas decorations from the Eight Mile Kelly Homeowners Association. (Courtesy of Sue Young.)

Giuseppe's Bakery is another Eastpointe establishment that caters to the many nationalities that have immigrated to the area. Owner Grace Mihailovski (left) and sales assistant Jessica Reyes are seen as they prepare locally made baked goods for the Easter holiday. Pictured are the traditional hot cross buns of Eastern Europe; Giuseppe's Bakery also prepares and sells Italian desserts, Polish angel wings, and Mediterranean baklava, to mention just a few. (Courtesy of Marco Catalfio.)

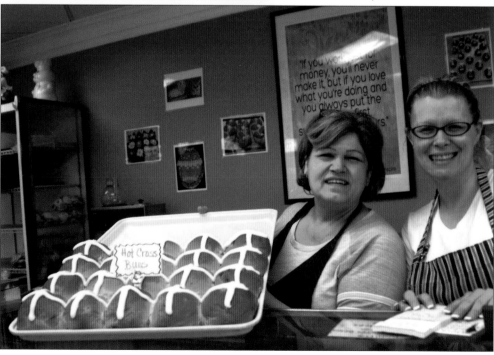

Girl Scouts have now become an adjunct to the Eastpointe Lions Club. Though the Lions always had a female group called the Lionesses, it was not until the year 2000 that women were admitted to the Eastpointe Lions. A local Girl Scout troop is seen here with Lion Kim Lubinski as they participate in the annual Ox Roast. (Courtesy of Eastpointe Lions.)

Eastpointe's Olive Garden restaurant was built at the site of the former Chesterfield Hall, which was once the site of an illustrious gambling casino. Long gone are the memories of the Sullivan-Fitzgerald duo that ruled three casinos within the East Detroit city limits. Banking on the number of Italian immigrants in the city, Olive Garden has been very successful even though it is one of the four city restaurants that cater to area Italians. (Courtesy of Marco Catalfio.)

A Eastpointe-based group, Communities That Care, developed the Eastpointe World Festival. The festival itself was patterned after the international festival that attracted East Detroit residents in the 1990s. Working closely with the parks and recreation department, downtown district authority, and the Eastpointe Chamber of Commerce, they were able to secure grants that brought international musical and dance groups to Eastpointe to teach about diverse cultures. (Courtesy of Sue Young.)

The Eastpointe World Festival brought residents of all ages to Rein Park. While the sound of international music attracted some, others came to taste the foods of different nationalities. Children were mostly attracted to the festival by the costumes. It was their time to try on traditional clothing of various cultures and spend the day imagining that they lived in distant lands. (Courtesy of Sue Young.)

Four

REDEVELOPMENT OF THE 1980S AND 1990S

By the 1980s and 1990s the entire picture of the city had begun to deteriorate. The number of schools were now exceeding enrollment. Many of the city buildings had additions, but their functionality was questionable as the heating and cooling systems became inadequate by today's standards. Windows and roofs leaked, and in many cases, the basements flooded during heavy rains, destroying stored materials. Though they were paid for, the expenditures for maintenance and energy were becoming cost prohibitive.

More so, computers were beginning to become a requirement for efficient administration, and most of the buildings did not have either the wiring or the capacity to add the technological equipment.

A freeway built in the late 1960s had siphoned off a great deal of the traffic that previously moved through the center of town. Shoppers no longer patronized the small stores in the shopping center but instead went to the malls or the big-box stores outside of the city for one-stop shopping. The Nine Mile Road–Gratiot Avenue area had deteriorated to the point that the only successful retail was a crumbling theater that showed pornographic movies.

Schools were now over built. Decisions made to eliminate buildings often brought residents to their feet when their children were affected.

Previous councils had pulled away from regional groups. There was a great deal of infighting on both the council and school boards. The ability for a city manager or school superintendent to hold a position in East Detroit for any length of time was questionable. The ability for either of them to have recommendations accepted was even slimmer.

Most of that began to change in the early 1980s when an election brought in new council members, who then hired a new city manager, Steve Banchak. Though young, he had experience with redevelopment in Southgate and took action almost immediately to set the city into a redevelopment phase. He advised the council to rejoin SEMCOG (Southeast Michigan Council of Governments), which advised application for a federal grant for a planning study to revitalize the Nine Mile Road and Gratiot Avenue area. That city manager left to assume a position in Florida, but the council hired Wes McAllister, who also had experience in redevelopment.

Wes is one of the rare city managers who lived within the city limits. As such, he was very involved with day-to-day activities and soon had a handle on the needs and what could be done

to remedy the problems. He worked closely with the council and schools to develop cost-sharing plans that were beneficial to both groups.

Aware of many of the potential civil rights issues that seemed prevalent during that time period, he set up procedures and policies to follow the law to the finest detail with all hiring and employee policies.

He developed a new economic development committee and hired a new economic development director who attracted new retail business as well as helping the older businesses through various problems. He hired a number of women who had completed the public administration or urban development programs at Michigan State University. He even hired a woman as assistant city manager. A new court building was added, and later, the municipal court was changed to a district court. Firefighters were all certified as ACLS providers and a new ladder truck was purchased.

When the study for Nine Mile Road and Gratiot Avenue was complete, he was able to set up a downtown district authority, which allowed complete revitalization of the central business district. East Brooke Commons was considered so far ahead of its time for a small city that the governor of Michigan, James Blanchard, came to the city for the ribbon-cutting ceremony. A brownfield committee was also established to renew vacant, contaminated properties. The Eight Mile Boulevard Association was formed to enhance the historical byway, and the chamber of commerce seemed to have a new shot of energy with the opening of East Brooke Commons. The Eastpointe Chamber of Commerce worked with the Eastpointe City Council initially to stage Cruisin' Gratiot, focusing on a parade of cars of all makes and models. It brought to light the joys experienced back in the 1950s and 1960s, when people would cruise along Gratiot Avenue to show off the power and looks of their cars. What started as a one-time event to bring people to Eastpointe has now expanded to an annual week of car shows, growing during the past 16 years so that it now attracts over 150,000 people.

There is however, one more major item that changed the face of the city. A man named George Lawroski had decided several years previously that the name of East Detroit was no longer appropriate. In the beginning, he had just a small following when he petitioned the council to place a name change on the ballot. Two different names failed in two different referendum elections, but during an August 1991 election, the voters approved changing the name of the city to Eastpointe.

The name change seemed to say that the community was ready for redevelopment.

Milo Hayes found himself in an unusual employment position when a newly elected Eastpointe City Council terminated the city manager, and the assistant city manager was hospitalized at the time with little chance of returning to work. In addition, the mayor died suddenly, leaving a council of four. Milo found himself now in charge, but since the charter states only the city manager can appoint employees, he was forced to assume all the responsibilities but with no power to hire or make decisions. The remaining four members of city council were often split 2-2, but they finally made a decision on a new city manager, Steve Banchak, and the problem was resolved. He is seen here on the right with Councilman Jim Kelly (left) and Nell Druzinski (center). (Courtesy of Sue Young.)

Councilwoman Flo Abke and Mayor Harvey Curley are seen here during one of the State of the City luncheons. This tradition began in the 1990s as a means of networking and updating local businesses on the local government issues. Today, it is an evening event with school and court officials also giving updates. (Courtesy of Sue Young.)

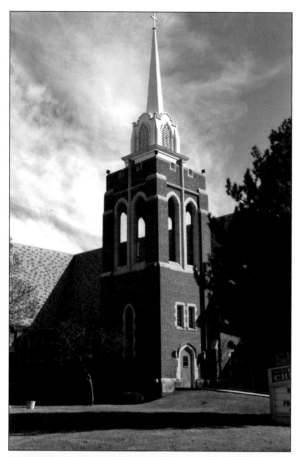

When St. Peter's Church moved to its new location in the 1950s, all available funds were used to build the new church and school. The congregation was able to build the bell tower and move the church bells, but the funds to replicate the old steeple were not there. Local businessman Jack Flath promised his wife that he would build it as a gift to her for their 50th anniversary, and in the 1990s, the new steeple appeared. (Courtesy of Marco Catalfio.)

Playground equipment was always considered essential on both school playgrounds and in city parks. Over the years, safety restrictions on equipment changed, frequently necessitating costly replacement. Seen here is an entire playground set that was funded and installed by the local Kiwanis Club. Bond issues in the 1990s helped to replace equipment on school playgrounds. (Courtesy of Sue Young.)

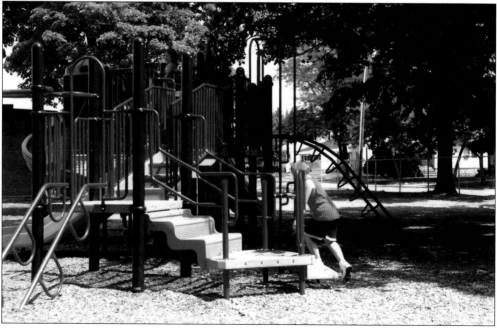

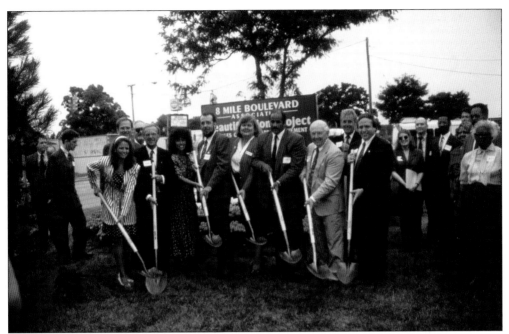

The Eight Mile Boulevard Association was first formed in the 1990s to provide the opportunity for the three counties, Detroit, and local cities and businesses to work together to improve the deteriorating historical byway, known as Eight Mile Road. Eastpointe was a charter member of the group and very involved with cleanup, median beautification, and code enforcement procedures. The board is seen here at the ground-breaking ceremony of the median gardens. (Courtesy of Eight Mile Boulevard Association.)

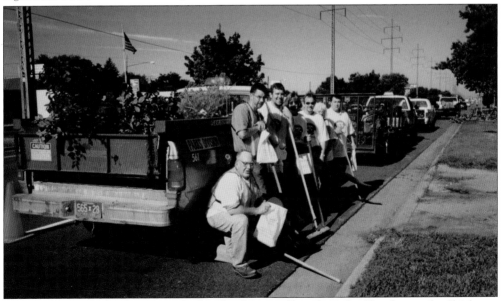

"Clean the D" was the slogan attached to the cleanup effort along the 17-mile stretch of highway. Seen here are Eastpointe city employees who were part of the team. From left to right, they are John Sage, Chris Delridge, Joe Lambdin, Linda Weishaupt, Steve Horstman, Mary Demsich, and Mayor Frank Accavitti. (Courtesy of Eight Mile Boulevard Association.)

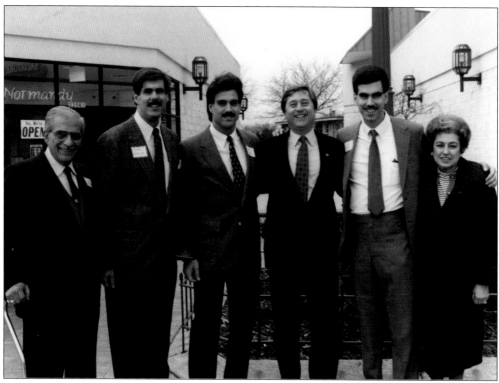

The Curis family joined Gov. Jim Blanchard (third from right) at the grand opening of East Brooke Commons. Led by George Curis (far left) and his wife, Millie (far right), sons George (second from left), Mike (third from left), and Dan (second from right) are seen here. The shopping center owned and maintained by the Curis family continues to be the center focus of Eastpointe's downtown area. (Courtesy of Millie Curis.)

City council leaders were also at the East Brooke grand opening, as each of them had been very involved in the development of the downtown district authority, which allowed for the redevelopment of the formerly deteriorating strip shopping area. (Courtesy of Sue Young.)

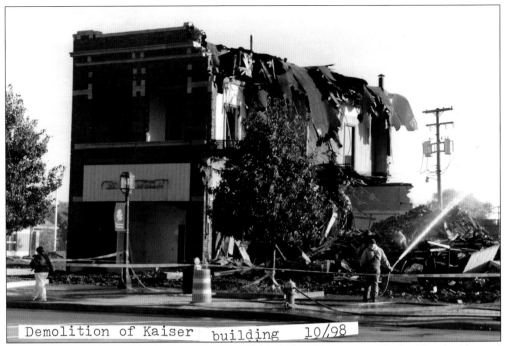

Demolition of Kaiser building 10/98

The Kaiser Building demolition in 1998 was a sad day for local historians. The building had housed the original offices for the Village of Halfway and the beginning of the city. Lack of maintenance and changes in city codes made the restoration costs prohibitive. (Courtesy of Ed Krupinski.)

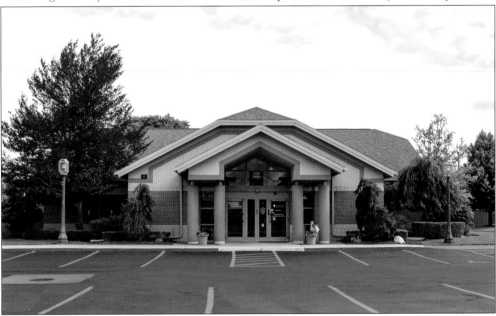

First State Bank was able to purchase and build on a piece of property located near the intersection of Nine Mile Road and Gratiot Avenue. It was less than a block from the site of the original 1917 bank. The bank has expanded many times since then and has offices scattered throughout Macomb County. There are even two more branches in Eastpointe; however, this branch is considered as the hometown branch. (Courtesy of Ashley M. Havovich.)

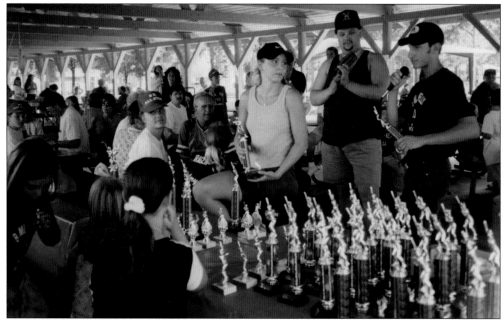

Kids' baseball has always been an important part of the East Detroit community. Several churches had their own leagues, but the largest group in the city was associated with the Eight Mile Kelly Homeowners. At one time, over 350 players in three different age levels played in the league. There was also an international group of players that frequently either played in Canada or invited the Canadians to play here. (Courtesy of Sue Young.)

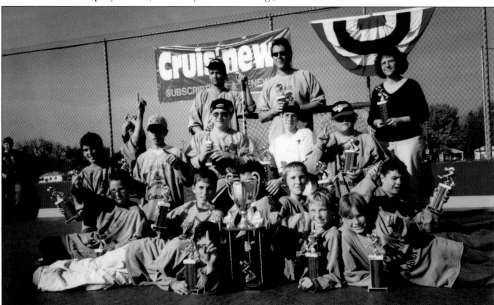

Roller hockey took the place of baseball starting in the late 1990s. As rollerblading became the new thing to do for adults, it also became the choice for teens. It was just a matter of time before they started playing hockey on rollerblades. Again, it was the Eight Mile Kelly Homeowners group who formed a league, under the supervision of Jay Brown. The league soon had 375 kids in three different age levels. (Courtesy of Jay Brown.)

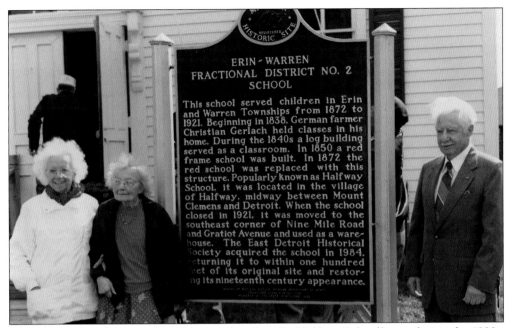

A Michigan State Historical Marker was placed at the Halfway Schoolhouse during the 1990s. In attendance at the special ceremony were five former students of the one-room schoolhouse. Seen here are Mini Puffpaff (left), Helen Slyker, and Jack Bieber. (Courtesy of East Detroit Historical Society.)

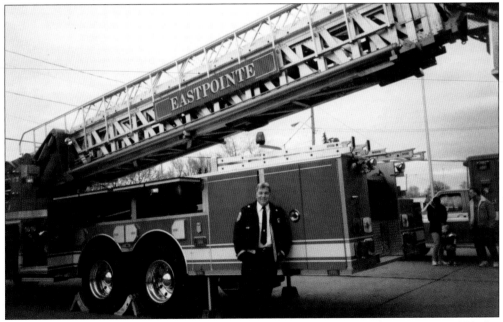

The ladder truck was a big occasion when it arrived at Eastpointe's fire department in 1998. An expensive item, it was deemed necessary since the senior housing units with 165 apartments were six stories high. It remains with the department today and has been most beneficial with large fires, assisting in high-level rescues as well as extinguishing fires from different ranges. Capt. Don Schmidt is seen here with the truck. (Courtesy of Nick Sage.)

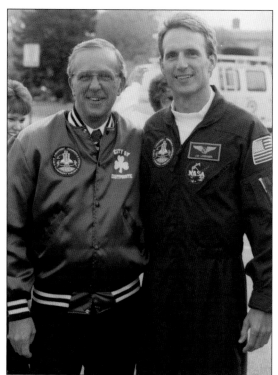

There was a huge citywide celebration when Eastpointe welcomed astronaut Jerry Linenger back to his hometown in 1997. A graduate of East Detroit High, Jerry had completed college at Wayne State and then received four different advanced-level degrees. He was a naval astronaut who had recently spent six months on the Russian space station *Mir*. He is seen here as he is welcomed to the city by Mayor Harvey Curley. (Courtesy of Harvey Curley.)

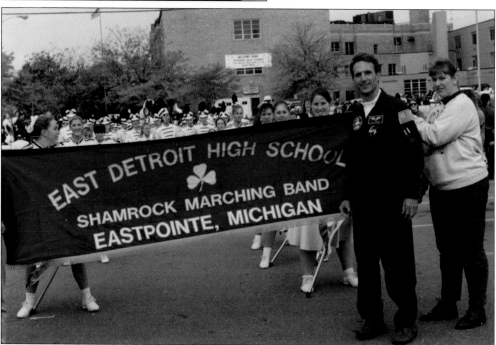

The East Detroit High School band welcomed Jerry to the high school. He was named the grand marshal of the annual East Detroit High School Homecoming Day Parade. Hundreds turned out for the parade, many of whom knew his father, Don, when he had served on the East Detroit School Board of Education. (Courtesy of the East Detroit Historical Society.)

The bleachers were packed with well-wishers when Jerry Linenger and his wife arrived at Memorial Field. It was a hero's hometown welcome, applauding Jerry's many achievements since high school. (Courtesy of the East Detroit Historical Society.)

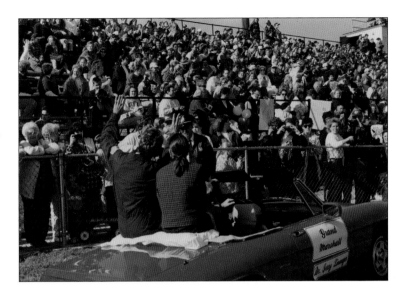

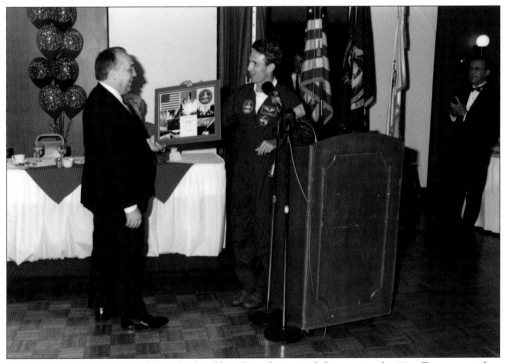

Later, Jerry Linenger joined hundreds of local residents and dignitaries for "An Evening with a *Mir* Acquaintance." Gov. John Engler led the parade of dignitaries presenting Jerry with a special award from the State of Michigan. Jerry is often quoted saying, "When flying in space, you cannot grow tired of looking back on Earth. My favorite location is looking at Michigan. It looks like a giant put his hand print on earth." (Courtesy of East Detroit Historical Society.)

At this Memorial Day parade, the Eight Mile Kelly Homeowners group chose to use a Zamboni to carry board members and promote the roller hockey league. A local business, Mueller Tool and Gear, actually made Zambonis used to clean ice for hockey arenas. The owners chose the parade to promote their business as well. (Courtesy of Sue Young.)

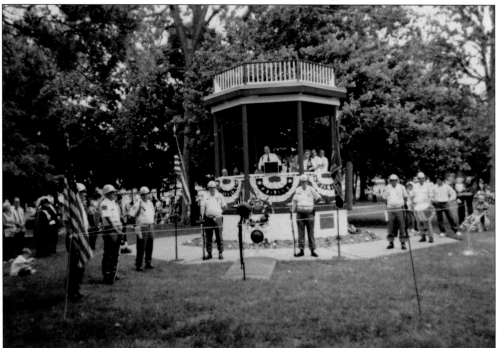

Memorial Day parades end at the gazebo built by the VFW in Kennedy Park. The short ceremony highlights the role East Detroit/Eastpointe has played in previous wars. (Courtesy of East Detroit Historical Society.)

Five

Changing Times of the 21st Century

To date, the 21st century has been a mixture of the very positive and very difficult times. The city began with an exuberant and positive outlook, but that has changed to a negative one. Through it all, the strong set of values that are inherent within the community and the ability of the city and school system to adjust have allowed survival through the worst financial crisis since the Great Depression. The ability to completely recover will not happen for 25 years because of the Michigan state tax structure.

During the Great Depression, people dealt with banking problems. During the recent Great Recession, two major events dramatically affected the local economy. The first was the slowing of the automotive industry due to overstocking, which led to stopping production and bankruptcy for two of the three major automakers. At the same time, the major housing crisis occurred with fraudulent mortgage practices. Coupled together, these two events had a huge negative impact on the majority of the city and state's population with rippling effects upon local city and school administration.

It goes without saying that no area should be totally dependent on one industry, but Detroit and other major cities in the southeast Michigan area are known as the Motor Capital of the world for good reason. Though there are many other businesses in the area related to research, education, finance, and health care, all of them are in some way dependent on the auto industry or the people that work in the auto industry. Slowing and then stopping of auto production changed the lives of many.

The numbers of both men and women who became unemployed escalated rapidly within a two-year period. A Macomb County report at one time estimated the rate of unemployment in Eastpointe at 20 percent. Many people had bought new homes with nothing down and with little understanding of mortgages. Many of them survived on their credit cards and assumed that they would soon be able to find employment once the automotive industry straightened itself out.

At the same time, the fraudulent mortgage practices began, and those who bought their new homes on adjustable-rate mortgages (ARMs) soon discovered that their mortgage payment had now been raised three or four times in one year, often doubling from the previous year. With no work and an inability to keep their homes, many moved completely out of state, leaving vacant houses. The county report estimated that Eastpointe had 1,000 homes that were in foreclosure,

1,500 in ARMs that were abandoned, and another 1,500 homeowners who would lose their homes in six months.

The community responded by wrapping its arms around families that were on the brink of financial disaster. Michigan State University Extensions set up classes on avoiding foreclosure and financial management. Parents welcomed back their children and grandchildren till they could find work. Churches set up counseling groups. Seven food banks were opened, and all were constantly used. Homeless shelters were established, many of which catered to families. Many breadwinners started new businesses, particularly landscaping and snow removal. Eventually, people went to work, the fraudulent mortgage practices were reduced, and families have survived though not fully recovered.

The effect on the schools was dramatic. School finance is based on the number of students enrolled. With large numbers of students exiting the district because of family unemployment, the revenue dropped rapidly. In addition, local tax revenue and operating funds dropped because of taxable value decreases, and the state decided to retain a large portion of education funding to cover its budget deficit. The number of elementary schools was reduced from seven to four, middle schools were reduced to one, administration was moved to the middle school, and secretarial and maintenance duties were outsourced. Former school property was bought by the city using Neighborhood Stabilization Program (NSP) funds and converted to senior housing.

Eastpointe's city revenue is also based on taxable revenue, a portion of state revenue sharing, and personal property tax. With each of these now greatly reduced or eliminated, the city has had to take actions to survive. Collaborative authorities with nearby cities for central dispatching and recreation were added to those already established for disposal and sanitary drains. Energy efficiency studies were done at all city buildings with modifications made to reduce costs. Staffs were reduced. Some services are now contracted out, and the city hall is closed one day a week. The city has been successful with its ability to recoil, but with continual cuts to its revenue from the state, the decreasing fund balance will not sustain it.

Survival of the city will depend on its ability to redevelop and a change of the state's tax structure. In the past 10 years, the city has embarked on major efforts to rebuild its infrastructure, rebuild old buildings, and rezone and redevelop other areas in the city. A change in the tax structure is questionable.

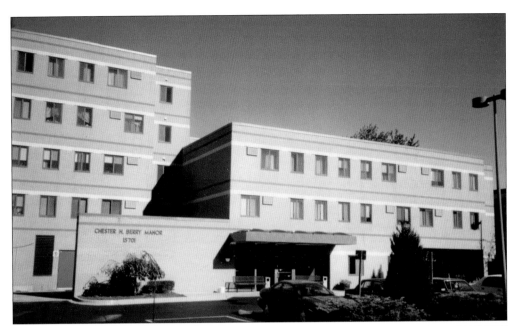

Chester Berry Senior Housing is the second senior complex located in East Detroit. Completed in 1984, it adjoins the first complex, Erin Manor, which opened in 1969. The complex is located on a seven-acre parcel on Nine Mile Road, just west of Gratiot Avenue. Together, they provide 164 units. Pictured here are two of Chester Berry's first residents. (Both, courtesy of Jodie Ling.)

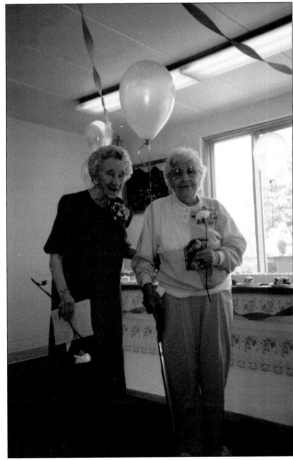

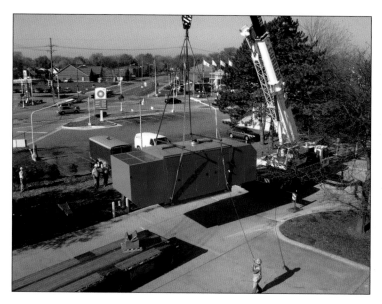

The Chapaton pump station and retention Basin at Nine Mile Road and Jefferson Avenue handles storm water and treatment of sewage from Eastpointe and St. Clair Shores. A recent bond issue provided this huge emergency generator, which eliminates down time in the event of any power loss. (Courtesy of Brent Avery.)

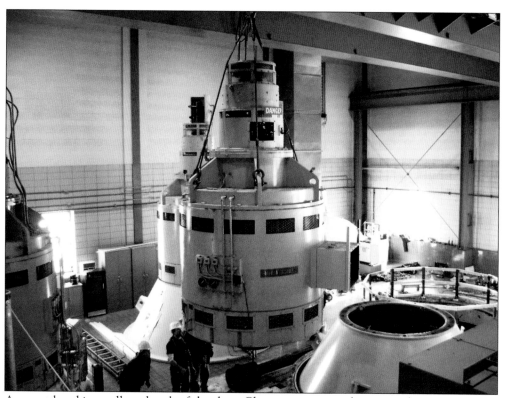

A recent bond issue allowed each of the three Chapaton pumps to be removed one at a time. A building wall was taken down, and the disassembled pumps were shipped to a manufacturer to be completely taken apart, reconditioned, and rewired. The size of these pumps can be noted when compared to the men standing next to them. (Courtesy of Brent Avery.)

Jim Winn once made the suggestion to Eastpointe Chamber of Commerce president Carol Corrie that it would be a great idea if the chamber hosted a local "cruise." Sixteen years later, Cruisin' Gratiot continues to be Eastpointe's major event, attracting 150,000 people to its main streets. Five days of car shows, entertainment, and parades now highlight the event. (Author's collection.)

The 1999 city council opened the first Cruisin' Gratiot with a prayer service in front of St. Peter's Lutheran Church. Pictured are, from left to right, Ed Young, Flo Abke, Mayor Harvey Curley, an unidentified person, Frank Accavitti, and Norene Redmond. (Courtesy of Sue Young.)

CITY OF EASTPOINTE
COURT BUILDING

CITY COUNCIL

HARVEY M. CURLEY	MAYOR
RONALD L. CAMPBELL, JR.	MAYOR PRO-TEM
FLO ABKE	COUNCILWOMAN
FRANK ACCAVITTI, JR.	COUNCILMAN
RICK HAGEN	COUNCILMAN
CARL F. GERDS III	MAYOR PRO-TEM
	(1991 - 1995)

MUNICIPAL JUDGES

BENEDICT SEGESTA MARTIN J. SMITH

BUILDING AUTHORITY

S. WESLEY McALLISTER, JR.	CHAIRMAN
JOYCE CONTE	SECRETARY
LARRY D. GORDIER	TREASURER
DANIEL S. FOECKING	TREASURER
	(1992 - 1995)

CITY OFFICIALS

ROBERT J. HRIBAR, JR.	CITY ATTORNEY
LEWIS L. HUNT	CHIEF OF POLICE

ARCHITECT/ENGINEER

ANDERSON, ECKSTEIN AND WESTRICK, INC.

GENERAL CONTRACTOR

BOLOGNA CONTRACTING CORPORATION

1996

"Where there is no vision, the people perish."
PROVERBS 29:18

Municipal court services outgrew the allotted space in the city hall in the 1980s. Multiple efforts were made for the design and construction of a separate building next to the police station, but it was not constructed until the 1990s. Shortly thereafter, the municipal court was converted to a district court, which allowed a wider variety of cases to be handled locally rather than making residents travel to the county circuit court. (Courtesy of Marco Catalfio.)

Ed Chesney maintained a studio in Eastpointe for over 40 years. As an artist, he had studied throughout Europe in all types of art, but it was portrait sculpture that won him accolades. He is seen here as he completes the 12-foot bronze *Fireman's Memorial*, which is located in Roscommon, Michigan. Other commissions include the *Physician's Memorial* at St. John Hospital in Detroit and the eight-foot bronze statue of Jack Miner in Kingsville, Ontario. (Courtesy of the Chesney family.)

The high school student assembly visits the Halfway Schoolhouse each year to see where education in Eastpointe began. It is a diverse, energetic group of students from all grade levels who meet monthly under the guidance of a government instructor. Their meetings provide a learning opportunity in parliamentary procedure, but their main role is to develop and implement a variety of projects that benefit students and the local community. (Author's collection.)

Eastpointe's Model T chemical fire truck was completely restored in a shared project between the fire department, the historical society, and Clover's Collision. Over a five-year period, it was taken completely apart, repaired, repainted, and put back together at a total cost of about $5,000. It was unveiled to the public during a Cruisin' Gratiot parade with Capt. Don Schmidt driving it and fire chief Dan Hagen sitting on the passenger side. (Author's collection.)

Civil War reenactors, with Civil War–era guns from the 21st Michigan Infantry, opened the annual Erin Halfway Days Festival. Annually, the East Detroit Historical Society hosts reenactors in Kennedy Park in an effort to describe the life faced by early area settlers. (Courtesy of Ken Giorlando.)

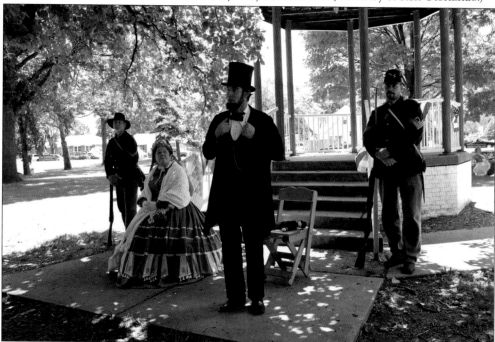

Fred Priebe was always a hit at Erin Halfway Days with his impersonations of Abraham Lincoln. Each year, he would present a different Lincoln speech, using the Bicentennial gazebo as the background. His close resemblance to Lincoln and his ability to replicate Lincoln's dialogue often made people think they had really gone back in time. (Courtesy of Ken Giorlando.)

Eastpointe Children's Garden was a collaborative effort by the Michigan State University Master Gardeners and Oakwood Middle School to transform a walk-through between two buildings into a garden where children could safely visit to watch nature at its best. A butterfly garden and two demonstration planters are available to teach children about gardening and the world around them. (Author's collection.)

Historical buildings are constantly in need of maintenance. Here, members of the Eastpointe Lions Club replace the sinking walkway and repaint the handicap ramp at the old schoolhouse. (Author's collection.)

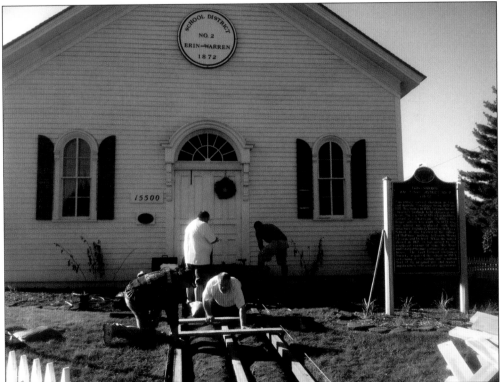

For the past 10 years, the Lions have held a fall festival in the downtown area of East Brooke Commons. Recognizing that most city children have had no experience with farm animals, they bring in a petting zoo and also offer pony rides. As one can see, the Eastpointe Harvest Festival petting zoo is one of the day's highlights. (Author's collection.)

Eastpointe's Lions also raise funds to support their philanthropy of helping the blind and others with sensory losses. At the Eastpointe Harvest Festival, they sell pumpkins for children to paint at the festival or to take home to carve. Funds raised with the pumpkin sale help the Lions in their work with the Penrickton Center, a home for children with severe sensory disabilities. Pictured here is Michigan state senator Steve Bieda. (Author's collection.)

Production Plating, Inc., was one of the few industrial buildings located along Eastpointe's main Gratiot Avenue corridor. A 1999 explosion and fire rocked the area, closing the street for several days. After a thorough investigation by the Environmental Protection Agency, the land was cleared and made available for sale. (Courtesy of Nick Sage.)

This early education center was built by St. Peter's Lutheran Church on the previous site of Production Plating. Architecturally, the design is a cruciform, allowing several separate sections for different age groups of children. The exterior bricks were coordinated with the architects of the new Eastpointe City Hall so that the bricks of the neighboring buildings would complement each other. (Courtesy of Marco Catalfio.)

Following restoration by the East Detroit Historical Society and the fire department, the No. 1 City Vehicle, the 1921 Model T, has received all types of honors for its authentic restoration. Although it is usually reserved for parades and car shows, it was recently on exhibit at the Macomb Community College Cultural Center's three-month exhibit highlighting the 1920s. (Courtesy of Marco Catalfio.)

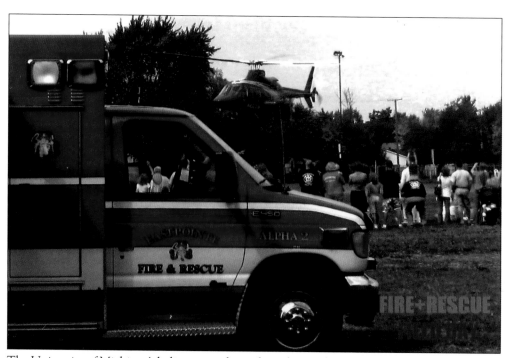

The University of Michigan's helicopter is shown here during the Eastpointe Fireman's Field Day. It was brought in to show the coordination needed during an emergency transfer of patients to the Ann Arbor facility. (Courtesy of Nick Sage.)

Eastpointe's Community Garden is a new addition to promote healthy nutrition, as well as to teach gardening. Members also distribute vegetables grown in the "Giving Gardens" to local food banks and senior housing. Drs. Lakin and Robert Schick are seen here giving the committee a $500 grant to help the project. Donations were also received from United Way, the Networking Forum, and the Eastpointe Rotary Club. (Author's collection.)

Eastpointe's Farmer's Market started in 2012 as another way to bring locally grown, fresh produce to the city's residents. It continues with farmers and other food-related vendors marketing their goods every Saturday morning in East Brooke Commons. (Author's collection.)

Michael Ferreri, a longtime senior housing volunteer, was honored in 2001 by having a new area at the facility named after him. A 49-year Eastpointe resident, he served on the housing commission for 16 years and also worked with the VFW and Eagles. The new facility is a large addition with a crafts room, a commercial kitchen, exercise mats, a television lounge area, and a game room. He is seen here on the right with fellow commissioner Jim Kelly. (Courtesy of Jodie Ling.)

Eastpointe's senior citizens currently make up about 30 percent of the population. Multiple senior housing facilities exist and include the Erin/Chester Berry Complex, Grant Manor, and more recently Oakwood Manor. Seniors are an active group, as seen in this picture of seniors filling the "Seniors Cruise Trolley" for a Cruisin' Gratiot parade. (Author's collection.)

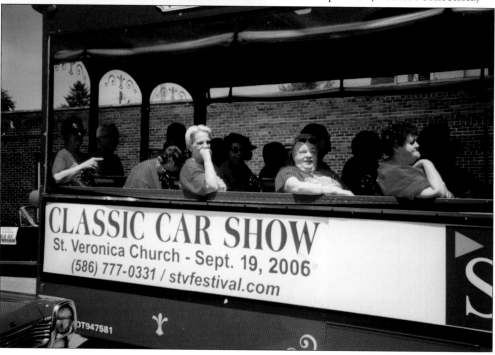

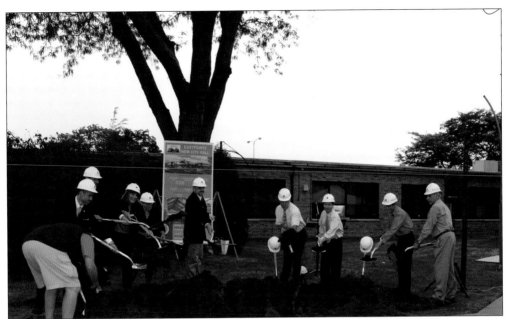

Following completion of months of planning for the new city hall, a ground-breaking ceremony was held. Seen here are architects, construction company officials, and the Eastpointe City Council. Also included is assistant city manager Randy Altimus, who was designated as the project manager over demolition of the old building and building of the new city hall in the same location. (Courtesy of Partners in Architecture.)

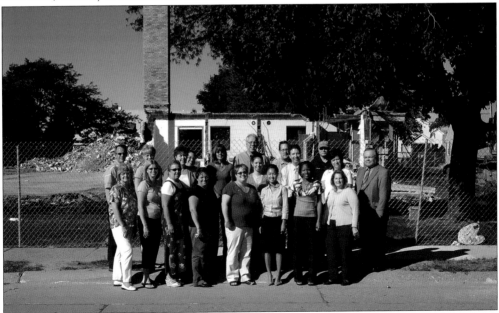

City hall employees watch the old city hall be demolished section by section. Many of these employees had never worked in another location, but each of them realized that the maintenance on the old building was far more than the construction of a replacement. The employees were temporarily housed in the former senior center during the construction period and then moved to their new offices 15 months later. (Courtesy of Kimmie Sharpe Rich.)

Unveiling of the new city hall plaque signaled the dedication of the new city hall in October 2008. Seen in this picture are, from left to right, assistant city manager Randy Altimus (front), Councilman Bill Sweeney (partially hidden behind Altimus) Mayor Suzanne Pixley, and former mayor Dave Austin. (Courtesy of Randy Altimus.)

The city hall open house followed the dedication ceremony. As one can see, residents were eager to see the inside of the new building and tour throughout the area. (Courtesy of Randy Altimus.)

The architects specifically designed the city council chambers so that residents could see through plate-glass doors to see elected officials in action. This symbolized transparency in government. Other features of the city hall are natural elements with stone and brick, advanced technology, a security system, easy to read signage, and multiple energy-efficient features. (Courtesy of Randy Altimus.)

City hall's open house brought in old and young alike to check out the new building. Displays were set up throughout the main hall to inform residents about current city services. Several local restaurants also served refreshments. (Courtesy of Randy Altimus.)

There is perhaps no other time of the year when the city hall is more crowded than at Christmas. Traditionally, residents fill the adjoining plaza, and the high school band plays Christmas carols while children sing along, patiently waiting for Santa's arrival. When he arrives, he is given the key to the city, and he leads the parade to Santa's village, set up in the city council chambers. (Courtesy of Randy Altimus.)

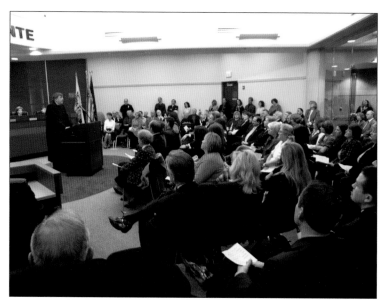

Shortly after the city hall was dedicated, Carl Gerds III was elected as 38th District Court judge. He chose to hold the installation in the city council chambers and the reception in the corridor. Eastpointe City Hall was packed with Michigan judges, dignitaries, friends, and family. (Courtesy of Randy Altimus.)

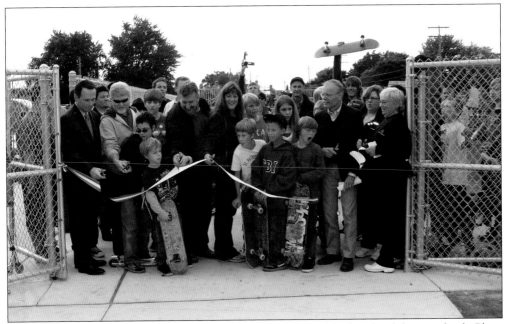

The City of Eastpointe qualified for $3.2 million in federal neighborhood stabilization funds. Plans were made to use the funds to benefit all generations. Property was purchased from the schools for new senior housing at the former Oakwood and Kellwood school sites. Demolition and rebuilding was also done in multiple locations at Kennedy Park. The ribbon-cutting ceremony at one of the projects, the Kennedy Skate Park, is seen here. (Courtesy of AEW Engineering.)

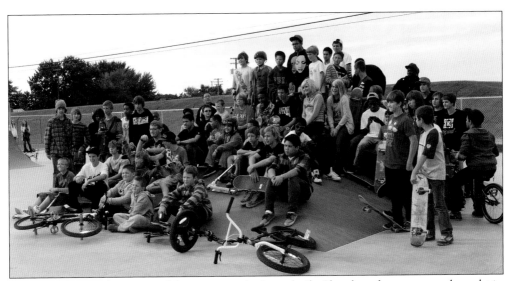

Kennedy Skate Park was one of the most popular items built. Skateboard experts were brought in by local churches to demonstrate safe practices, as well as some of the most difficult maneuvers. The park continues to be one of the most used locations in Eastpointe. (Author's collection.)

DeRonne's is an example of an Eastpointe business that builds its success on customer service. In 2013, it received the regional True Value trophy for being rated as Best Hardware Store in Town. It was one of 13 stores chosen from across the country. DeRonne's is a true family store with the father and mother, Paul and Lorrie, and son and daughter, Dave and Diane, all involved in the business. (Author's collection.)

Street reconstruction is inevitable in an aging community. There is often no way to eliminate the inconvenience of street closures when a busy street is being reconstructed. Despite all efforts, the construction period creates downtimes for local businesses. Pictured here are Diane and Mike Seger, owners of Clover's Collision, as the orange barrels were lifted, signaling the reopening of Stephens Street. (Courtesy of Clover's Collision.)

Major decreases in tax and state revenue to the city could have meant the end of the former parks and recreation department. By working with the neighboring city of Roseville, however, a Recreational Authority for Roseville and Eastpointe (RARE) allowed creation of joint recreation, run by a board with representation from both cities. Seen here are team members of the RARE youth baseball league as they shake hands with the Detroit Tiger mascot, Paws. (Courtesy of Tony Lipinski.)

The Chapaton solar panels are seen here. Eastpointe has become more energy efficient wherever possible. Recently, the cities of Eastpointe and St. Clair Shores turned on the switch to activate a large number of solar panels that will collect solar energy to be used by the Chapaton pumps to control drain and sewer flow. This was a joint project of both cities and was partially funded with a federal grant. Seen here from left to right are Congressman Sander Levin, Eastpointe mayor Suzanne Pixley, and St. Clair mayor Kip Wahlby. (Author's collection.)

Using neighborhood stabilization funds, the City of Eastpointe purchased two closed school properties from the East Detroit Public Schools. Kellwood was demolished shortly after purchase, but plans were submitted to the US Department of Housing and Urban Development to renovate Oakwood School to create senior apartments. The plans were initially rejected and then again six months later. An alternate plan to demolish and rebuild for senior housing was then submitted and approved. Oakwood is seen here at the start of demolition. (Courtesy of Ken Giorlando.)

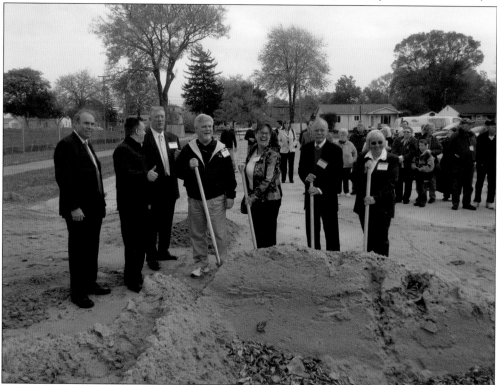

Breaking ground began on the new two-story building once the demolition was complete. Shown here are local residents, Eastpointe and HUD representatives, architects, contractors, and the senior housing management team. (Courtesy of Bill Driskell.)

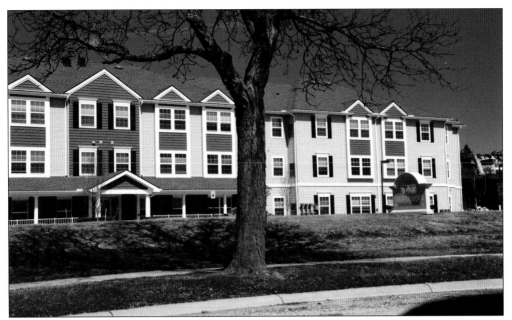

Oakwood Manor is now complete. It was 100-percent occupied when its grand opening was scheduled. The senior complex is complete with a community room, patio, library, crafts room, laundry rooms, beauty shop, and so much more. Each apartment has a living room, kitchen, and walk-in closet and is handicapped accessible. A new gazebo and walking paths have been added. (Author's collection.)

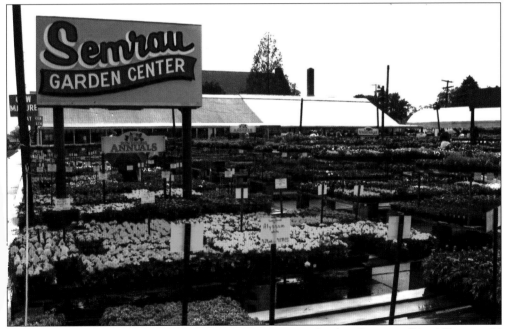

Although it has reduced its sales season in 2014, Semrau's Garden Center will be 100 years old in the spring of 2015. It is still owned by the same family and is at its original location. It is true family-run business in Eastpointe, bringing meaning to the town's motto—"A Family Town." (Courtesy of Marco Catalfio.)

INDEX

BIBLIOGRAPHY

Campbell, Bob. "Incumbents Bounced in County: Biggest Upset in East Detroit." *Macomb Daily* November 18, 1977.

Christenson, Robert S. *The Halfway–East Detroit Story.* Carrol Bratt and Esley Rausch, eds. East Detroit, MI: East Detroit Historical Society, 1979.

Clyne, Jean. "East Detroiter's Work Earns a Bandstand." *Detroit News* April 8, 1976.

Lorenzi, Lillian. "Decision Made for Block Grant." *C&G Papers: Eastsider* June 13, 1984.

Thomas, Charles. "City Gets Slogan, Thanks to Scouts." *Macomb Daily* June 2, 1975.

Zineski, Tony. "East Detroit: A Developed Residential Community." *Macomb Daily.* February 25, 1972.

Discover Thousands of Local History Books
Featuring Millions of Vintage Images

Arcadia Publishing, the leading local history publisher in the United States, is committed to making history accessible and meaningful through publishing books that celebrate and preserve the heritage of America's people and places.

Find more books like this at
www.arcadiapublishing.com

Search for your hometown history, your old stomping grounds, and even your favorite sports team.